IMAGES
of America

ELLIS ISLAND'S
FAMOUS IMMIGRANTS

Wretched Refuse?

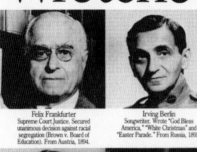
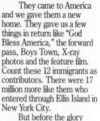

Felix Frankfurter
Supreme Court Justice. Secured unanimous decision against racial segregation (Brown v. Board of Education). From Austria, 1894.

Irving Berlin
Songwriter. Wrote "God Bless America," "White Christmas" and "Easter Parade." From Russia, 1893.

Charles Proteus Steinmetz
"The Wizard of G.E.," he was the first scientist to create lightning in a laboratory. From Germany, 1889.

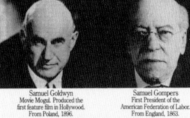

Dr. Michael I. Pupin
Physicist and inventor. Took the first X-Ray photo in America. Arrived from Austria in 1874 with only five cents in his pocket.

Samuel Goldwyn
Movie Mogul. Produced the first feature film in Hollywood. From Poland, 1896.

Samuel Gompers
First President of the American Federation of Labor. From England, 1863.

Knute Rockne
Football Coach. Invented the forward pass and led Notre Dame to 5 undefeated seasons. From Norway, 1893.

Spyros P. Skouras
President of Twentieth Century-Fox. Introduced CinemaScope. From Greece, 1910.

William S. Knudsen
President of General Motors. Perfected the moving production line. From Denmark, 1900.

Elia Kazan
Actor, writer, director of plays and films. Directed "On The Waterfront," and wrote "America, America." From Turkey, 1913.

Father Edward Flanagan
Founder of Boys Town in Omaha, Nebraska. From Ireland, 1904.

Samuel Chotzinoff
Pianist and music critic. Popularized classical music with NBC broadcasts. From Russia, 1895.

They came to America and we gave them a new home. They gave us a few things in return like "God Bless America," the forward pass, Boys Town, X-ray photos and the feature film. Count these 12 immigrants as contributors. There were 17 million more like them who entered through Ellis Island in New York City.

But before the glory came the dream. A dream embodied by the Statue of Liberty. Abroad these people might be the "huddled masses" and the "wretched refuse." Here they were soon accepted as Americans. And their noteworthy achievements are treasured as our own.

Now it is your turn to be a contributor. Both the Statue of Liberty and Ellis Island are deteriorating and must be restored. The Foundation established to carry out this important work needs your help. Your donation will preserve the glory of those who passed this way before. And the dream of those who may pass this way again. Send your gifts to:

The Statue of Liberty/
Ellis Island Foundation
P.O. Box 1992, Dept. P
New York, New York 10008

This advertisement created as a public service by Eidson, Speer, Watson & Hughes, Kansas City

WRETCHED REFUSE? To raise money in order to restore certain buildings on Ellis Island, the Statue of Liberty-Ellis Island Foundation developed this clever advertisement. Playing on two of the more provocative words of Emma Lazarus's celebrated poem juxtaposed with the famous faces of a few outstanding immigrants, it served as a reminder of the unexpected legacy of historic mass migration. (Ellis Island Foundation.)

On the cover: **ARRIVAL.** Despite high hopes of seeing the glorious Statue of Liberty, arriving immigrants often made careful preparations for the sometimes-grueling immigration inspection awaiting them on Ellis Island. The picture was taken on board the British liner *Olympic* in the early years of the 20th century. (Library of Congress.)

IMAGES
of America

ELLIS ISLAND'S FAMOUS IMMIGRANTS

Barry Moreno

ARCADIA
PUBLISHING

Published by Arcadia Publishing
Charleston SC, Chicago IL, Portsmouth NH, San Francisco CA

Printed in the United States of America

Library of Congress Catalog Card Number: 2007931355

For all general information contact Arcadia Publishing at:
Telephone 843-853-2070
Fax 843-853-0044
E-mail sales@arcadiapublishing.com
For customer service and orders:
Toll-Free 1-888-313-2665

Visit us on the Internet at www.arcadiapublishing.com

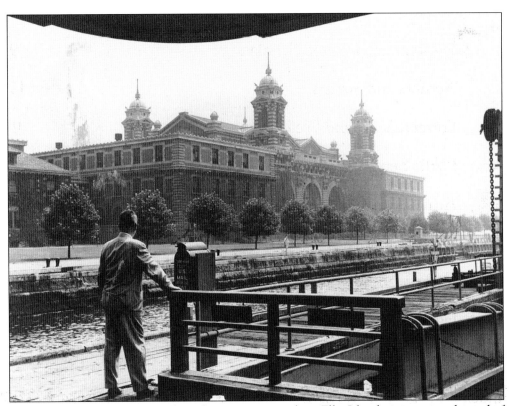

ELLIS ISLAND'S LAST DAYS. When this picture was taken, Ellis Island was nearing the end of its service as the nation's most important immigrant control station. In the last years before it closed in 1954, the press began recounting its six decades of operation. (Immigration and Naturalization Service/National Park Service.)

CONTENTS

ACKNOWLEDGMENTS

I am exceedingly grateful to those who kindly assisted me as I pursued this hobby over the years. My colleague at Ellis Island Kevin Daley and New York City's commissioner of records Brian G. Andersson have both helped me with a number of immigrant celebrities that passed through Ellis Island. Kevin Daley drew my attention to several possible individuals, including someone I would never have thought of—Sir Charles Kingsford-Smith, the Australian aviator. Brian G. Andersson found the records for me of Béla Lugosi and Claudette Colbert. Others have also been of help to me in my longtime search for the famous. I gratefully thank Peg Zitko at the Statue of Liberty-Ellis Island Foundation, Catherine Daly of the American Family Immigration History Center, David Diakow, Bela G. Lugosi (son of the actor), Beulah Robinson (niece of Edward G. Robinson), Charles Roman (Charles Atlas's business partner), Bob Hope (whom Kevin Daley and I met and I spoke with on his last visit to Manhattan), Louis Nizer (whom I spoke to over the telephone), the office of John W. Kluge, Isabel Belarsky (daughter of Sidor Belarsky), Alfred Levitt (whom I met at Ellis Island and Greenwich Village), Eric Byon, Paul Sigrist, Diana R. Pardue, George Tselos, Jeffrey Dosik, Janet Levine, Doug Tarr, Ken Glasgow, Doug Treem, Dennis Mulligan, Loretto D. Szucs, and Virginia Haroutunian. I must also acknowledge the assistance of the late popular singer Arthur Tracy, who became a real friend and regaled me with his memories of old-time show business and fellow thespians such as Al Jolson, Irving Berlin, Max Factor, Gus Kahn, Al Dubin, Arthur Murray, and Samuel Chotzinoff. The images in this book are from the collections of the National Park Service, Library of Congress, National Archives, and author.

INTRODUCTION

Ellis Island—its very name evokes memories of immigrants in the thousands entering its elegant main building each week to apply for admission to the United States. People from every walk of life, people from many parts of the world, but predominantly from Europe, trod its walkways and halls as they underwent the several stages of the bureaucracy confronting them. Once passed and approved at America's eastern gate, they settled in urban and rural areas throughout North America and occupied themselves as common laborers, factory and mill hands, miners, skilled craftsmen, and shopkeepers. They reared families and hoped that their American-born offspring might achieve the American dream of attaining a decent education, household ownership, a professional career, and riches. This was the common experience of most of Ellis Island's immigrants. However, there were others, a small number, to be sure, who had different ideas. They were not content to wait for the possible successes of the next generation. They wanted success for themselves and they wanted it now. And so, armed with a dream and a goal, these immigrants struck out on their own, challenged fortune, and, in their own ways, won. This book tells the story of some of the best known of these personalities.

The persons selected for this book were chosen for several reasons. These include how prominent they were in their own lifetime and within their own spheres of influence, the interest that their stories might arouse in today's readers, the accessibility of their biographies and immigration details, the availability of attractive visual material of them or about them, and finally their name recognition for a 21st-century audience.

As for the final requirement, I was often compelled to sigh and reluctantly admit the truth of the poet Virgil's undying words *tempus fugit*, for many of my subjects, who once excited so much interest during certain phases of their lives, have now almost faded from popular memory. Sad but true. But this fact coupled with the incidental detail that all of them underwent immigration scrutiny at Ellis Island makes the need for this book, in my view, very real. For the well-known figures of yesteryear tell much about our culture and society today—how we recognize achievement or failure in public life; clamor before our favorite performers; are moved by the creative force of our artists, writers, thinkers; and admire the forethought and persistence of those who have succeeded in the arenas of business, politics, and organized labor. Such a volume can just remind us where our society has been and possibly foretell something of its future.

This is a subject very near and dear to my heart. The idea for it occurred to me when I first came to work at Ellis Island, just before the opening of the current immigration museum. My assignment was to reopen the library, whose books had lain in boxes in the damp New Immigration Building since the departure of the last librarian, Won Kim. Once I had the library set up in cramped quarters in one of the old hospital buildings, I read through the research files and in so doing found a list of famous Ellis Island immigrants. It bore 18 names. Amazed at such

a miniscule number, I vowed to search for others who might also have come through. This I did in my spare time. By consulting published memoirs and biographies, historic press reports of immigration and other records, I gradually enlarged the list; now I have well over 100 famous immigrants. This I have shared with colleagues, researchers, and visitors over the years and am now fortunate enough to make at least a portion of it available to readers in the form of this book.

Missing from this volume are a good many notables for whom I have no visual materials. These many remarkable Ellis Islanders include photojournalist Lucien Aigner (Hungary), boxer Enrico Bertola (Italy), candy manufacturer Sam Born (Russia), popular historian Max I. Dimont (Finland), painter Max Ernst (Germany), crime photographer Arthur Fellig (popularly known as "Weegee," Poland), Tin Pan Alley songwriter Fred Fisher (whose hit songs included "Come, Josephine in My Flying Machine," "Peg O' My Heart," and "Chicago," Germany), character actor Wallace Ford (England), religious author Rabbi Hyman E. Goldin (Russia), rock music promoter Bill Graham (Germany), Prime Bishop Francis Hodur (Poland), Assyriologist Samuel Noah Kramer (Ukraine, Russia), actress Eugenie Leontovich (Russia), cubist sculptor Jacques Lipchitz (Lithuania), restaurateur George Mardikian (Armenia), Col. Tom Parker (Elvis Presley's manager, the Netherlands), journalist James Reston (Scotland), hardware and appliance dealer P. C. Richard (the Netherlands), author Salom Rizk (Syria), jazz singer Annie Ross (Scotland), painter Mark Rothko (Latvia), comic actor Sig Ruman (Germany), drama teacher Lee Strasberg (Austria), composer Jule Styne (England), and lyricist Jack Yellen (whose hit songs include "Ain't She Sweet?," "Happy Days Are Here Again," and "My Yiddishe Momme," Poland).

One

SPIRITUAL LEADERS AND SCHOLARS

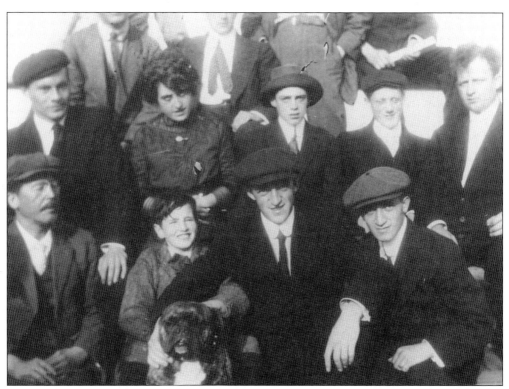

EDWARD FLANAGAN IN STEERAGE. The future founder and director of Boys Town is the big fellow in the middle foreground of this picture taken on board the steerage deck of the RMS *Celtic*; the great ship docked in New York harbor on August 27, 1904. Pictured with Edward Flanagan is his younger brother, Patrick, who also became a Roman Catholic priest. Fr. Edward Flanagan was born in Leabeg, County Roscommon, Ireland, in 1886. In his boyhood, he was a shepherd.

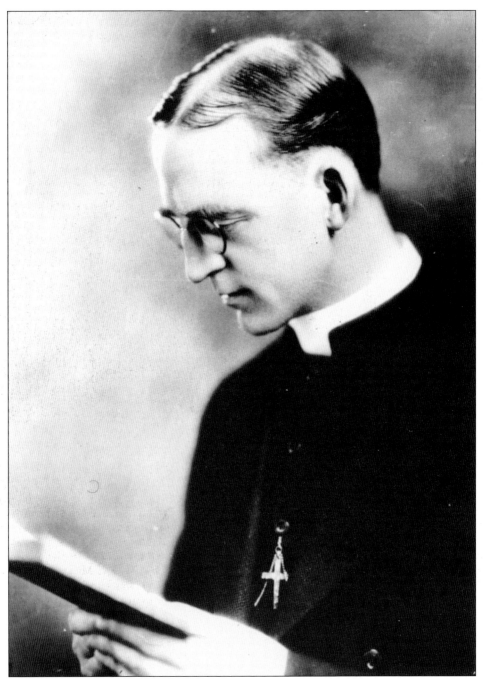

FATHER FLANAGAN'S MISSION. Edward Flanagan was educated at the seminary at the Royal Imperial University at Innsbruck, Austria, and he was ordained to the priesthood in 1912. Accepted by a Nebraska diocese, he founded his orphanage for delinquent boys in 1917. Years later he said, "When the idea of a boys' home grew in my mind, I never thought of anything remarkable about taking in all of the races and all of the creeds. To me, they are all God's children. They are my brothers. They are children of God. I must protect them to the best of my ability."

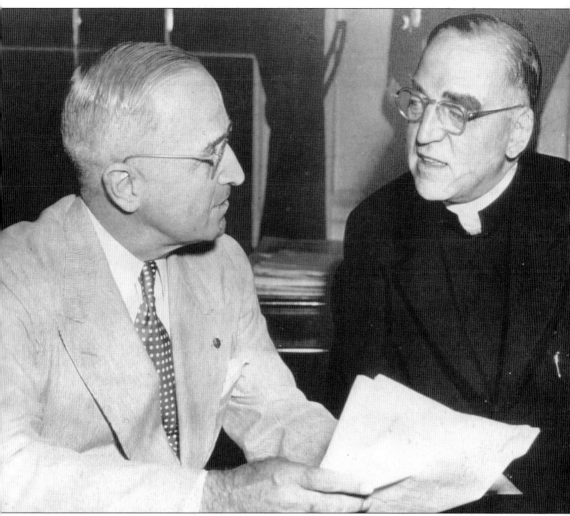

MONSIGNOR FLANAGAN WITH PRESIDENT TRUMAN. Flanagan's work at Boys Town won him national recognition, and he truly became a hero to the American people. He was interviewed and consulted on juvenile delinquency, and his struggles were dramatized in the Academy Award–winning film *Boys Town* (1938), which starred Spencer Tracy and Mickey Rooney. In 1937, he was raised to the rank of monsignor and, after the war, was sent by Pres. Harry S. Truman to help orphans in Japan and Germany. He died in Berlin in 1948. Currently there is a movement supporting his canonization to sainthood.

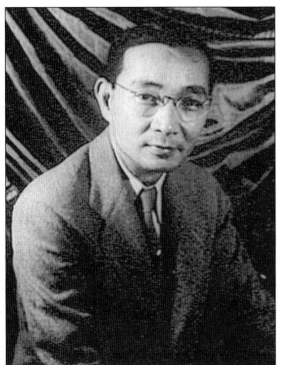

LIN YU'TANG. The distinguished scholar Dr. Lin Yu'tang (1895–1976) popularized classic Chinese literature in the West. He came to America for university studies and pursued postgraduate work in Germany. On his return to the United States in 1931, he was briefly detained for Chinese inspection at Ellis Island. His intelligent and witty books, including *My Country and People* (1935), *The Importance of Living* (1939), and *Between Tears and Laughter* (1943), endeared him to western readers and increased interest in China. He also published a Chinese and English dictionary, invented a Chinese typewriter, and wrote novels. He died in Taiwan, and his home there is now a museum.

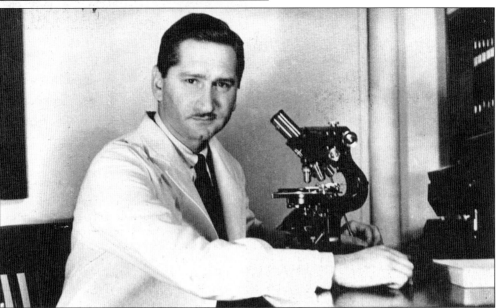

ALBERT SABIN. With his parents, Jacob and Tillie Saperstein, and sister, Albert Saperstein passed through Ellis Island and settled in New York. The boy grew into a man and found for himself a new name, Albert Bruce Sabin. The family left behind the difficult life in their native city of Bialystock, Russia (now Poland), and America offered previously unreachable opportunities. Albert (1906–1993) became a physician but was soon drawn to medical research. He joined the fight to find a cure for polio. His contribution was astonishing; it was a "live virus" vaccine taken orally, and it effectively eliminated polio from the United States.

KRISHNAMURTI. Theosophy's former world messiah, Jiddu Krishnamurti (1895–1986) was briefly detained at Ellis Island to look into an accusation of moral turpitude during an American visit on August 22, 1926. But after having questioned him, Ellis Island's commissioner Benjamin M. Day passed him as innocent. Krishnamurti later settled in California and became a leading philosopher and explorer of the human condition. (*The New Book Revelations: The Inside Story of America's Astounding Religious Cults* by Charles W. Ferguson.)

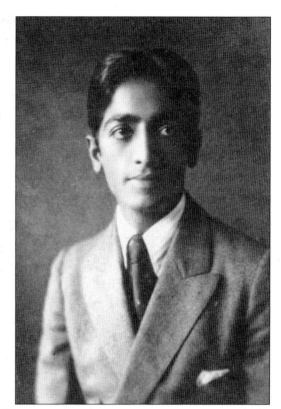

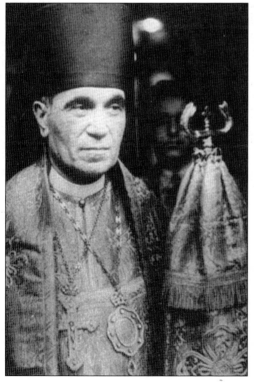

FAN S. NOLI. Theophan Stylian Noli (1882–1965) first came to the United States in 1906, after which he was ordained an Orthodox priest and also took a degree at Harvard University. As an assertion of Albanian independence, he and others founded the Albanian Orthodox Church for which he was consecrated a bishop in 1919. After this, he became a political leader in newly independent Albania and briefly served as prime minister. Soon a reversal in his political fortunes forced him into exile, and when moving back to the United States in October 1932, he was briefly detained at Ellis Island.

PARAMAHANSA YOGANANDA. The distinguished swami Paramahansa Yogananda made several trips to America, and most appeared to be smooth sailing, until one of them landed him at Ellis Island for investigation. This was one he made on the *Bremen* in October 1936. It appears that his use of two names, Mukunda Lal Ghosh and swami Yogananda, occasioned suspicion, and he was detained for special inquiry. He soon satisfied officials as to his identity. The swami is famous for his Self-Realization Fellowship institution in Los Angeles.

GERMÁN ARCINIEGAS, SCHOLAR AND DIPLOMAT. Dr. Germán Arciniegas's stay at Ellis Island was a trifle unusual. He was taken by immigration agents at the airport on a return from a visit to France on the evening of September 17, 1953, and taken to Ellis Island on a security charge. But next morning, he was merely asked whether he had ever criticized U.S. relations with a Latin American country, to which he answered in the affirmative. Next his passport was inspected, and then he received an apology and was released from custody. The problem arose over confusion about how to enforce the McCarran Walter Act. Arciniegas taught for many years at Columbia University and was a former minister of education; he later served as an ambassador.

Two

AUTHORS AND ARTISTS

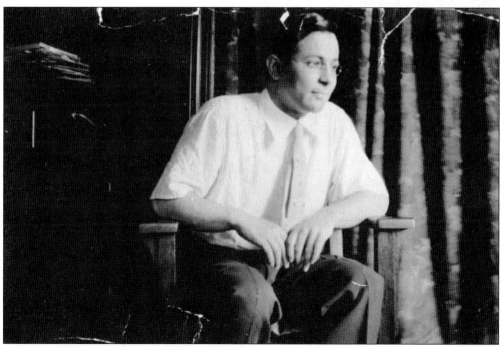

GARIBALDI MARTO LAPOLLA. In November 1894, little Garibaldi Marto LaPolla (1888–1954) arrived in New York on board the SS *Burgundia* with his mother and sister Clorinda; from Ellis Island, they made their way by rail to Montreal to join his father, a baker. Like many southern Italians, LaPolla's father journeyed far in search of work. Eventually the family settled in East Harlem, Manhattan's second-biggest Italian community. LaPolla was educated at Columbia University and became a high school English teacher. His love of literature soon led him to a career in writing.

THE GRAND GENNARO. Garibaldi Marto LaPolla's most celebrated work is his novel *The Grand Gennaro* (1935). Taking Italian immigrant life in East Harlem in the early 20th century as its theme, it was the first novel to seriously address the difficulties Italians were faced with in their American environment. His other novels are *Fire in the Flesh* (1931) and *Miss Rollins in Love* (1932).

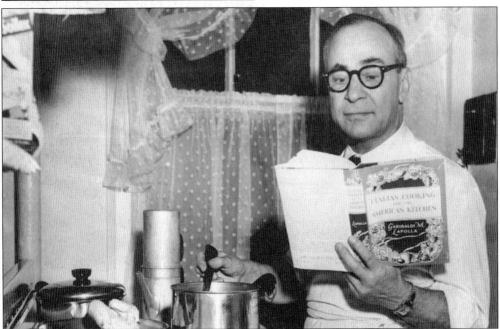

LAPOLLA'S ITALIAN COOKERY. LaPolla also wrote several nonfiction books, including two cookbooks. In this picture from 1953, he is demonstrating one of his recipes from his new book *Italian Cooking in the American Kitchen*. His other works were *The Mushroom Cookbook* (1953), *Better High School English* (1929), *Junior Anthology of American Poetry* (1929), *World's Best Poems* (1932), and *Grammar in the New York Public Schools* (1937).

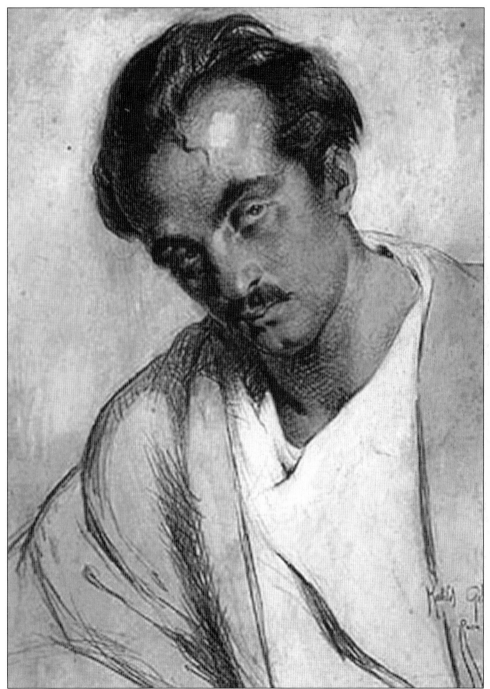

Kahlil Gibran. This 1914 portrait captures something of the unique personality that was Kahlil Gibran's. The 12-year-old Gibran left his native Syria (Lebanon) with his family in 1895. From Ellis Island, they went to Boston. As an adult, Gibran made his mark in poetry and other writings, using the Arabic, Syriac, and English languages. His most celebrated book is *The Prophet* (1923), a perennial best seller. The great Arab Christian poet died in New York City in 1931.

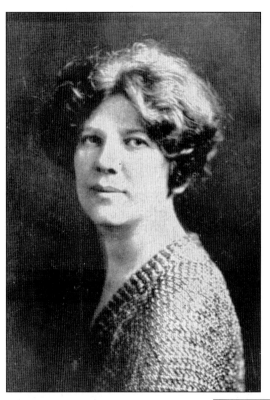

ANZIA YEZIERSKA. The writer Anzia Yezierska (1880–1970) came to America from Poland in 1892; the family changed its name to Mayer, and she became Harriet (Hattie) Mayer. As an adult, she changed her name back to the original and took up her pen and began writing stories. Her perennial theme was the passionate struggle of Jewish immigrant women in becoming Americans and coping with assimilation. Her best-known works are *Hungry Hearts, Bread Givers, Salome of the Tenements,* and *Children of Loneliness.* Her fiery, wistful, passionate characters with their hopes and dreams have been labeled "Cinderellas of the Tenements."

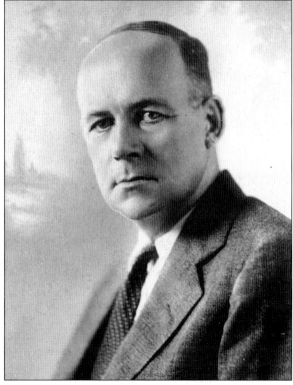

OLE RØLVAAG. Famous for his novels of Norwegian immigrant life on the Dakota prairies, Ole Rølvaag (1876–1931) came to America in 1896 from a fisherman's life in the country. After working as a farmhand in South Dakota, he began his college studies, which culminated with his return to Norway in 1905 to get his doctorate. In 1906, he once more passed through Ellis Island, this time in steerage aboard the *Caronia.* Rølvaag taught Norwegian literature and language at St. Olaf's College, Minnesota, from 1906 to 1931. His best-known novels, *Giants in the Earth* and *Peder Victorious,* were originally written in Norwegian.

JOSEPH STELLA. A futurist painter acclaimed for the industrial imagery that dominated much of his work, Joseph Stella (1877–1946) came to America in 1896 from his native town of Muro Lucano, Potenza province in Basilicata, Italy. His earlier work reflected the more traditional themes of human existence, especially life in the slums, but his return to Italy (1909–1913) opened his eyes to modernism and its physicality. Among his works are *New York Interpreted* and *Brooklyn Bridge*.

ALFRED LEVITT. This photograph of the artist was taken when he 105 years old. Alfred Levitt (1894–2000) left czarist Russia with his family in 1911; they settled in the East Harlem section of upper Manhattan. Levitt was introduced to painting by Robert Henri and continued his work over the years, most notably at the summer art colony in Gloucester, Massachusetts. His last major art exhibit was at the Ellis Island Immigration Museum in 1997. His most recognized works include *Paysage Provençal* and *Growth and Fruition*.

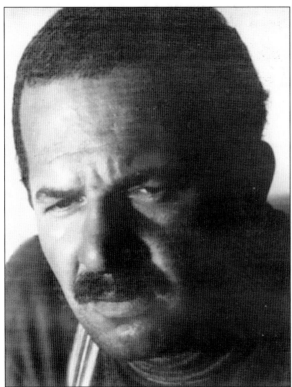

BEN SHAHN. One of the foremost social realist painters of his time, Benjamin Shahn (1898–1969) and his family came from Kovno, Russia (Lithuania), in 1906. They settled among other Russian Jews in Williamsburg, Brooklyn. He picked up his first art training while working as a lithographer's apprentice. In the 1920s, he went to Paris to study art seriously and in 1932 won public recognition with his series on the trial and execution of the Italian anarchists Nicola Sacco and Bartolomeo Vanzetti. This work established his credentials as a politically driven artist with a deep concern for social justice.

FARMERS. This somber work by Shahn depicts the grim, hard life that American farmers endured during the Great Depression. The work dates from 1943.

THE MUSEUM OF THE CITY OF NEW YORK
and
ARION PRESS
cordially invite you to attend

A TRIBUTE TO
HENRY ROTH

Thursday, February 29, 1996, 6:00 to 7:30 p.m.
at the Museum of the City of New York
and
Saturday, March 2, 1996, 3:00 p.m.
at the Lower East Side Tenement Museum

HENRY ROTH. Novelist Henry Roth (1906–1995) left Tysmenitz, Galicia, Poland (Austria), with his mother in 1907. Growing up in New York, Roth was deeply influenced by the literary stylists James Joyce and T. S. Eliot. In 1934, he produced an accomplished piece of his own, *Call It Sleep.* This novel about a Jewish immigrant family quickly became a classic, which apparently drove its shy author underground, for he produced no other significant work for the next 60 years. Long after retiring from a round of common jobs, he produced a quartet of novels called *Mercy of a Rude Stream* (1990s).

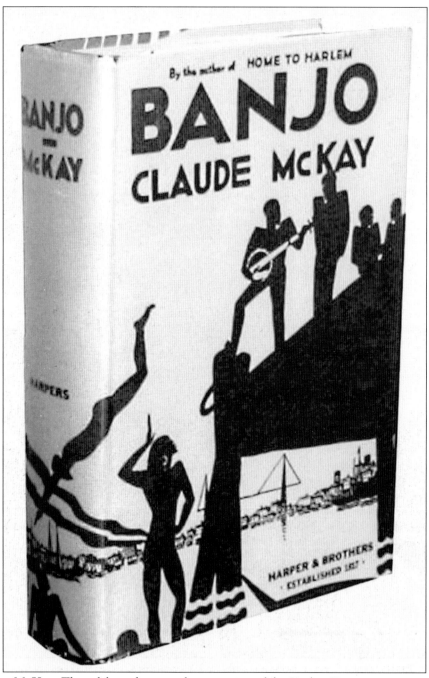

CLAUDE MCKAY. The celebrated poet and prose writer of the Harlem Renaissance was a native of Jamaica. In 1912, he came to the United States to study agronomy but soon gave it up and began pursuing his literary interests while waiting tables on trains. His famous sonnet "If We Must Die" (1919) appeared during antiblack racial tensions, and in the memoir *A Long Way from Home* (1937), he discusses his travels and passing through Ellis Island. His other works include *Songs of Jamaica* (1912), *Home to Harlem* (1928), *Banjo* (1929), *Gingertown* (1932), *Banana Bottom* (1933), and *Harlem: Negro Metropolis* (1940).

LUDWIG BEMELMANS. Forever famous thanks to his engagingly illustrated stories for children, Ludwig Bemelmans (1898–1962) sailed to New York second class on board the Dutch steamer *Rijndam*. With only the equivalent of $10 in his pocket, the Austrian lad was promptly detained at Ellis Island until he got out by simply convincing the inspectors that he was going to his "father" Lambert Bemelmans in Manhattan. Well, as he boarded the Ellis Island ferry he must have been laughing up his sleeve since it was his brother Lambert who lived in New York. Bemelmans wrote many books, including *Hansi* (1934), *Madeline* (1939), *Hotel Splendide* (1941), *Madeline's Rescue* (1953), and *Madeline and the Bad Hat* (1956).

LOUIS ADAMIC. As a writer, Louis Adamic (1899–1951) was profoundly concerned by America's low opinion of immigrants and the difficulties of assimilation that foreigners faced in the United States. Adamic's concerns are expressed in his many books, including *Laughing in the Jungle* (1932), *The Native's Return* (1934), *My America* (1938), and *Two-Way Passage* (1941). Born Alojzi Adamic, he was a Slovenian and came to the United States in December 1913 as a second-class passenger on the SS *Niagara*. With only $7, he was detained until his uncle Alois took responsibility for him.

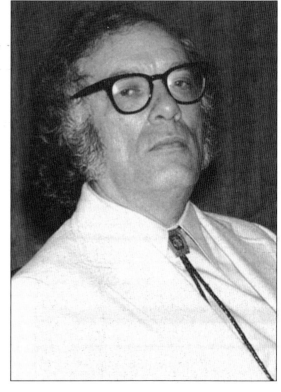

ISAAC ASIMOV. The renowned science fiction writer Isaac Asimov (1920–1992) was happy to recount his family's emigration from the Soviet Union in 1923. On their arrival at Ellis Island, Isaac, sick with measles, was hospitalized until his recovery. The Asimovs settled in Brooklyn and operated a candy shop. Isaac studied science and earned his doctorate in biochemistry. But it was his fiction that made him famous, particularly such works as *I, Robot* (1950), *Pebble in the Sky* (1954), and *The Naked Sun.*

ARSHILE GORKY. Two young Armenian refugees from Turkey sailed on the *President Wilson*; they arrived at Ellis Island in February 1920, and Arshile Gorky (1904–1948), then known as Manouk Adoian, was briefly detained for a more thorough medical examination. Despite his pallor, he was healthier than they had expected. The teenage siblings left by train to join their father, Setraz Adoian, in Providence, Rhode Island. Arshile Gorky struggled throughout his life to express his artistic vision, but he suffered from the tragic memories of his people in Armenia. Notwithstanding this factor or perhaps because of it, he was a seminal force in abstract expressionism. Below is a portion of his exquisite painting *The Artist's Mother* (1938). It shows his beloved mother, Shushan Adoian, who starved to death during the genocide against the Armenian people. His other outstanding works include *Nighttime, Enigma, Nostalgia,* and *Agony*.

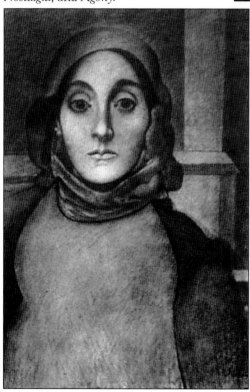

ONORIO RUOTOLO, SCULPTOR HERE

Portraitist in Stone Dies— Carved 'Freedoms' Plaques

Onorio Ruotolo, a sculptor whose final work was presented to Vice President Humphrey on Saturday, while the artist lay gravely ill, died of a heart ailment yesterday in his home at 20 Bank Street in Greenwich Village. He was 78 years old.

A plaque by Mr. Ruotolo, "The Four Freedoms," was awarded to the Vice President by the Italian-American Labor Council of New York at its silver jubilee celebration in the Commodore Hotel. The council presented a similar plaque by the Italian-born sculptor to President Franklin D. Roosevelt in 1944.

ONORIO RUOTOLO. Listed as a 19-year-old carver from Cervinara, Italy, on the steerage manifest of the *Moltke*, Onorio Rafaelle Ruotolo was discharged from Ellis Island in January 1908 and headed for Little Italy. Years of struggling with poverty followed, but he remained devoted to his art and also began writing prose and poetry. Ruotolo's sculptures include *Theodore Dreiser, Arturo Toscanini, Enrico Caruso, Benito Mussolini,* and *The Four Freedoms.*

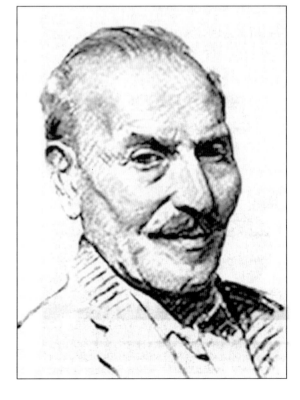

GEORGE PAPASHVILY. Sculptor and writer George Papashvily traveled in steerage aboard the *Megali Hellas*, which sailed from Constantinople and arrived in New York in August 1922. The chauffeur, 24, was listed as Georges Papachvily. The young Georgian who claimed to be a Turkish subject at last began his adventures as a penniless immigrant in America, some of which he humorously recounted years later in his best-selling memoir, *Anything Can Happen,* which sold 1.5 million copies worldwide. It was made into a motion picture in 1952 and starred José Ferrer. His other works include *Thanks to Noah* and *Home and Home Again.*

JOHN HERMES SECONDARI. The future American ABC television producer and novelist John Hermes Secondari was brought to this country by his mother. Traveling first class on the SS *Providence*, which set sail from the port of Naples in late May 1924, they were briefly detained at Ellis Island. Secondari (1919–1979) worked as a journalist both for newspapers and television. In the latter branch, he became famous for his historic documentaries for the ABC network and earlier had served as chief of its Washington bureau. He was the moderator on the television series *Open Hearing*. But he is best remembered as the author of *Coins in the Fountain* (1952), which was made into the 1954 Academy Award–winning film *Three Coins in the Fountain*. A fellow Ellis Island immigrant, Jule Styne (1905–1994), wrote the music for the film, which included its highly popular theme song that bears the same title.

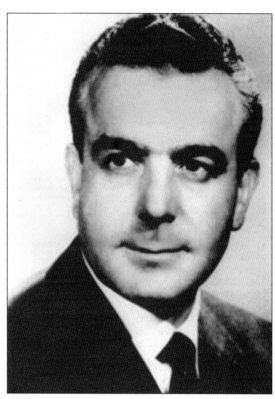

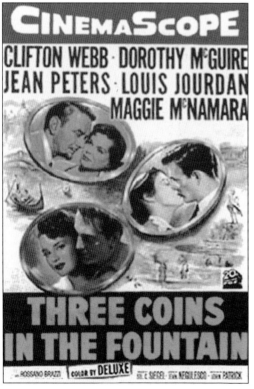

AYN RAND. Born and educated in
St. Petersburg, Russia, Alisa Rosenbaum
studied literature at the University of
Petrograd. In 1926, she received permission
to visit relatives in Chicago. Arriving
on a six-month tourist visa, her visit to
Ellis Island in February 1926 was brief.
Impressed by Manhattan, she took the
train to Chicago and apparently had no
sincere plans of returning to Russia. From
Chicago, she went to Hollywood to work
in motion pictures. There she wrote scripts
and plays and married her husband, Frank
O'Connor. Adopting the name Ayn Rand,
she continued her writing career but soon
switched to literature and produced a set of
fine novels, including *We the Living* (1936),
Anthem (1938), *The Fountainhead* (1943),
and *Atlas Shrugged* (1957). The last two titles
were best sellers and remain immensely
influential. Philosophically, she developed
a unique interpretation of objectivism
in which she laid emphasis on rational
self-interest, individual freedom striving,
and consensual laissez-faire capitalism. In
1999, the U.S. Postal Service issued a stamp
honoring her in the literary arts series.

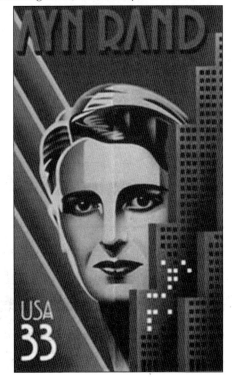

H. T. Tsiang. The talented Chinese writer, dramatist, and actor H. T. Tsiang (1899–1971) came to the United States in 1926, and he studied briefly at Stanford and Columbia Universities. His political background drew him into leftist circles where he blossomed as a writer. From mere journalistic propaganda he graduated to the higher arts of poetry, drama, and fiction; he also evolved into an actor. His major published works are the rebellious poem "Chinaman, Laundryman," (1928); a volume of poetry, *Poems of the Chinese Revolution* (1929); and the novels *China Red* (1931), *The Hanging on Union Square* (1935), and *And China Has Hands* (1937).

CHINESE AUTHOR GETS AID

H. T. Tsiang at Ellis Island to Be Defended by Committee

The American Committee for Protection of Foreign Born, 79 Fifth Avenue, has engaged counsel to defend H. T. Tsiang, Chinese author and dramatist, who is being held at Ellis Island, pending decision in deportation proceedings.

Immigration officials contended that Mr. Tsiang broke his residence under a student's visa here, when he failed to resume his studies at the beginning of this year. The committee said Mr. Tsiang failed to resume his studies because of ill health, but, at the time he was held for deportation, had arranged to continue his classes at Columbia. Ira Gollobin has been retained as attorney for Mr. Tsiang.

H. T. Tsiang in Hollywood. In the film capital of the nation, Tsiang became a character actor in movies and television; it is also possible that he appeared in local stage plays. His screen credits include *The Purple Heart* (1944), *The Keys of the Kingdom* (1944), *China Sky* (1945), *Tokyo Rose* (1946), and *Winter a Go Go* (1965). In the 1960s, he appeared on many televisions series, including *Wagon Train*, *Bonanza*, and *Gunsmoke*.

FRANCES WINWAR. An immensely popular biographer of the mid-20th century, Frances Winwar (1900–1985) put aside her Italian identity by anglicizing her name in a most extraordinary way and then concentrated her mind on literary success. The result was a spate of wonderful biographies on celebrities as diverse as Oscar Wilde, Napoleon Bonaparte, Percy Shelley, Walt Whitman, Gabriele D'Annunzio, Edgar Allen Poe, and Joan of Arc. She also translated Giovanni Boccaccio's *Decameron*. Privately, Winwar had a dramatic love life, for she married the notorious Communist writer and propagandist Victor J. Jerome, then Prof. Bernard Grebanier, and finally English-born mystery novelist Richard Wilson Webb. A native of Taormina, Sicily, Winwar came to New York as Francesca Vinciguerra on the *Citta di Torino* in June 1907.

Three

ENTREPRENEURS AND PROFESSIONALS

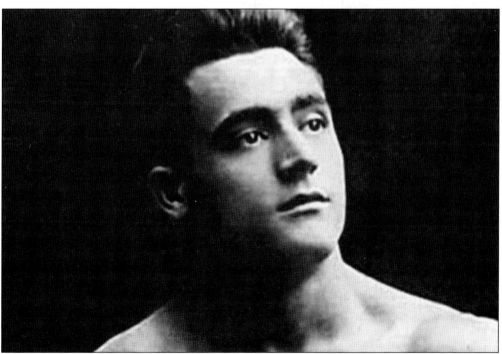

CHARLES ATLAS. Italian immigrant Charles Atlas (born Angelo Siciliano) created the most popular bodybuilding course of the 20th century. So successful was it that it spread the world over and attracted generations of students. Angelo Siciliano (1893–1972) was born in Acri, Italy, and the boy sailed to America with his grandparents and mother on board the SS *Roma* in a voyage in steerage that took two weeks. Arriving at Ellis Island on September 11, 1903, they were detained for special inquiry as the grandparents had medical problems. But not being dangerously serious, they were all released and allowed to proceed to their new home in New York City.

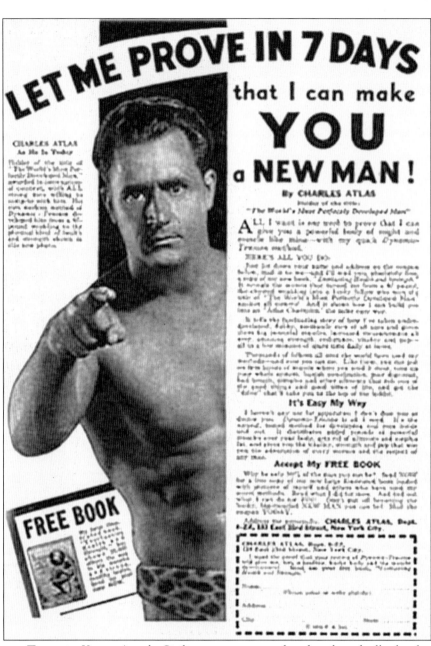

DYNAMIC TENSION. Young Angelo Siciliano grew to manhood and gradually developed his physical strength; the taunts of other youths made him aware of this need. In the 1920s, his attractive looks and physique helped him start a career as an artists' model. Inspired by the success of bodybuilders Eugene Sandow and Bernarr Mcfadden, he became a strongman at Coney Island and then began selling his dynamic tension exercise program through the popular press, especially comic magazines. With the advertising genius of Charles Roman, he achieved unparalleled success in his field. As years passed, the legend of Charles Atlas grew, and he received correspondence from all over the world. Since his death in 1972, the business he founded, Charles Atlas, Ltd., continues to offer its creator's special training technique of pitting muscle against muscle as the way to attain physical strength.

ARTHUR MURRAY. The man who made ballroom dancing even more widely popular than it was never admitted to being foreign born, but in truth, the remarkable Arthur Murray (1895–1991) was typical of the ambitious immigrant generation from which he sprang. A Polish Jew, Moses Teichmann (who changed his name to Arthur Murray) sailed to the New World with his mother and sister in steerage aboard the SS *Friesland* from Antwerp. From Ellis Island, they went straight to the Lower East Side.

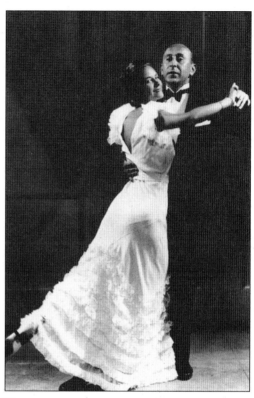

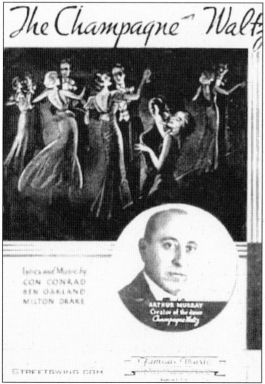

ARTHUR MURRAY IN MUSIC. In 1942, Johnny Mercer and Victor Schertzinger wrote the novelty song "Arthur Murray Taught Me Dancing in a Hurry" for the musical comedy film *The Fleet's In*. It was a big hit for comedienne Betty Hutton. Murray was delighted with it, and his studios continued to expand. By 1964, there were over 3,000 worldwide. Murray also had a hit television show, the *Arthur Murray Dance Party* (ABC, 1952–1964).

33

MAX FACTOR. The world's most famous cosmetologist is none other than Max Factor (1877–1938), who introduced pancake makeup and other innovations that glamorized the stars. He created a special look for actresses that set them apart. He gave bee-stung lips to Clara Bow and made Jean Harlow a platinum blonde; similarly he perfected the looks of Joan Crawford, Norma Shearer, Claudette Colbert, Barbara Stanwyck, and Bette Davis. A barber from Lodz, Poland, 30-year-old Max Factor, with his wife and three children, journeyed to the port of Hamburg, Germany, and from there took steerage accommodations on board the SS *Moltke*. They arrived at Ellis Island in February 1904 and from there went to St. Louis. Eventually they went to Hollywood, and by 1914, he began making his mark in the movie industry.

LOUIS NIZER. A brilliant trial lawyer, Louis Nizer (1902–1994) was a wizard at contract, copyright, divorce, and libel law. Further, his spellbinding oratorical skills put him in demand, and he handled the cases of public figures such as Salvador Dali, Mae West, and Charles Chaplin. Nizer was only four when his mother, Bella, brought him to New York to join his father, Joseph, a tailor.

MORRIS MARKIN OF CHECKER CABS

Company Founder, Who Led Fleet Here, Dies at 77

Special to The New York Times

KALAMAZOO, Mich., July 8 —Morris Markin, founder and president of the Checker Motors Corporation died yesterday at Bronson Hospital after having suffered a heart attack. He was 77 years old.

Mr. Markin, who once operated the dominant taxicab fleet in New York City, came to this country from Smolensk, Russia, in 1913 as a penniless immigrant. A janitor at Ellis Island paid the $25 bond needed to permit his entry into the country. Within a year Mr. Markin had saved enough to send for his parents, seven brothers and two sisters.

In 1918, with a brother, he started a trousers factory in Chicago, but soon after got into the taxicab business. He lent a friend $15,000 and then took over after the friend's cab-manufacturing concern ran into financial trouble.

Manufactured Superba

MORRIS MARKIN. For much of the 20th century, the Checker Cab Company reigned supreme among New York City taxicabs. This achievement was the brainchild of a Jewish immigrant from Smolensk, Russia, named Morris Markin (1892–1970). So poor was he on his arrival at Ellis Island in 1912 that he had to borrow $25 from a janitor to convince the inspector to let him in the country. From the garment industry, chance put him in the cab business, and from that point there was no turning back.

The Last Impresario

THE LIFE, TIMES, AND LEGACY OF SOL HUROK

SOL HUROK. The greatest impresario of his time, Solomon Hurok (1888–1974) embodied the spirit of a mad love for great art coupled with entrepreneurial genius. During his truly extraordinary career, he dazzled Americans by bringing to theaters some of the greatest artists of the world. Feodor Chaliapin, Michel Fokine, Efrem Zimbalist, Artur Rubenstein, Anna Pavlova, Isadora Duncan (who was detained at Ellis Island), Marian Anderson, the Comédie Française, and the Bolshoi Ballet were among his many clients. Hurok recounted his rise from a poor immigrant peddler to the heights he reached in his autobiography, *Impresario* (1946).

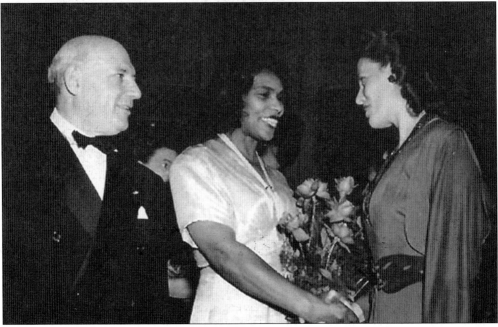

GAYELORD HAUSER. To Gayelord Hauser (born Helmuth Eugen Bengamin Gellert Hauser), the answer to many people's health problems was an improvement in diet; "Eat better, live longer," he always advised. Hauser was an early advocate of yogurt, blackstrap molasses, wheat germ, brewer's yeast, powdered skimmed milk, and laxatives (like his Swiss Kriss). His self-help nutritional books were published as far back as the 1920s. Hauser left his native town of Tübingen, Germany, and set sail on board the SS *George Washington*, from Bremen. The young steerage passenger was inspected at Ellis Island on August 14, 1911. By rail, he traveled to Chicago, where his brother, Otto, was a Lutheran pastor. But tuberculosis forced him to return to Germany to seek a cure. This he found in a Catholic monastery; its basis was simple: a wholesome diet. He returned to America, and the rest is history. He is pictured with his client Greta Garbo.

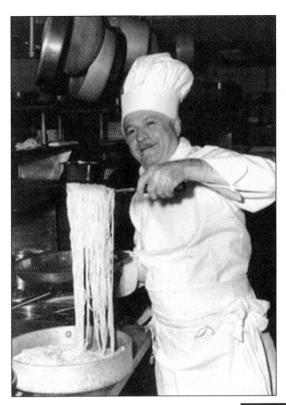

ETTORE BOIARDI, "CHEF BOYARDEE." Although Chef Boyardee canned pasta hardly represents the best of Italian cuisine, it serves its purpose, and moreover, it attracted millions of Americans to Italian food. Begun in the 1930s, the Chef Boyardee label became popular at a time when Italian restaurants were mostly found in Italian neighborhoods. Chef Boyardee changed all that. Ettore Boiardi (1897–1985) left Borgonovo, Italy, and sailed to America on the French ship *La Lorraine* in May 1914. The teenage steerage passenger went to join his brother Paolo in Manhattan.

JOHN KLUGE. The billionaire founder of Metromedia and generous philanthropist established himself as a major entrepreneur, media tycoon, and investor decades ago. Johannes Kluge was born in Germany, and in September 1922, he journeyed in the steerage class of the SS *George Washington* with his parents; their destination was Detroit, Michigan.

LILLY DACHÉ. It is difficult to believe that the queen of chic chapeaus came to America in 1919 with only $13, but such is the case. Lilly Daché (1893–1990) was apprenticed to a milliner when a girl in her hometown south of Paris. After emigrating, she saved money and opened her own millinery shop in New York. She was already achieving fame by 1923. For decades she dominated style at a time when ladies selected a hat before choosing the rest of the wardrobe. Her clients included fashionable stars such as Marlene Dietrich, Carole Lombard, Loretta Young, and Audrey Hepburn. She retired in 1968 and died in France. Her autobiography, *Talking through My Hats*, was published in 1946.

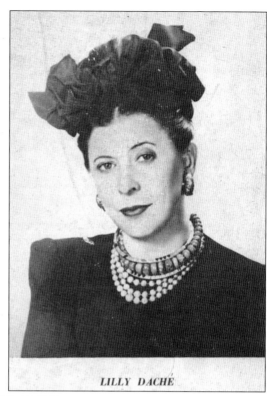

LILLY DACHÉ

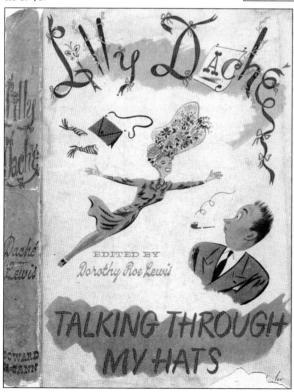

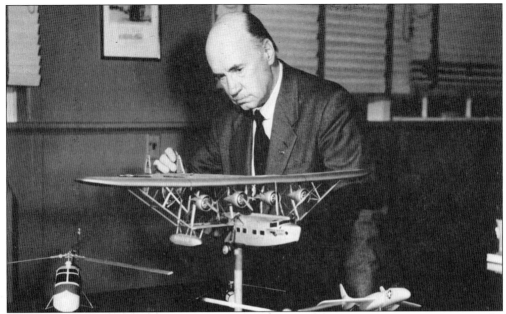

IGOR SIKORSKY. The man who perfected the helicopter came to America as a refugee in the wake of the bloody Bolshevik Revolution in Russia. Like many émigrés loyal to the czar, Igor Sikorsky (1889–1971) had to find a new life. He continued his pioneering work in aviation and at last achieved success with his Vought Sikorsky 300 helicopter. Sikorsky came to the United States on board the SS *Lorraine* in March 1919.

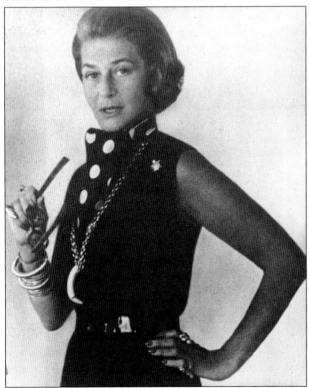

PAULINE TRIGÈRE. In 1937, with her marriage falling apart, Pauline Trigère (1909–2002) came to America to begin life anew. With her strong background in dressmaking, she easily found work in the fashion trade. In 1942, she opened her own establishment and made a name in the business within three years. She was famous for her handbags and other creations and remained in demand through the 1970s.

Four

PUBLIC SERVANTS AND UNION LEADERS

ABRAHAM D. BEAME. Yes, even a poor immigrant could aspire to the mayoralty of America's grandest metropolis, New York City. After working as a schoolteacher, Abraham D. Beame (1905–2001) served in various fiscal offices before serving as mayor (1974–1977). During his tenure, the city was on the verge of bankruptcy. Beame was born Abraham Birnbaum in London, England, of Polish Jewish parentage, and he came to America in August 1906 on the *Etruria* with his mother, Esther Birnbaum, and two brothers.

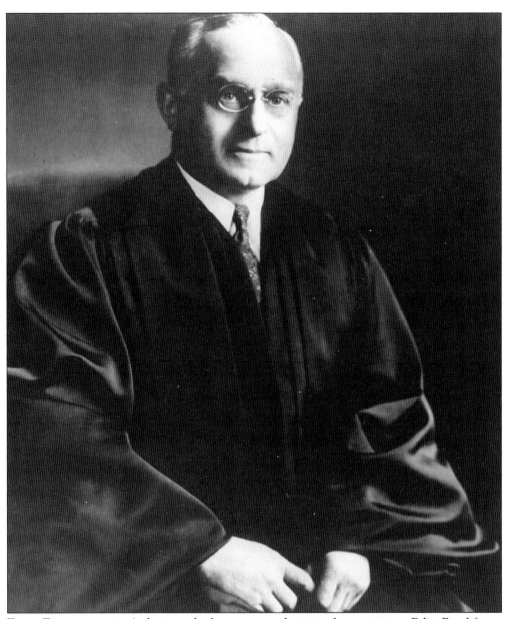

FELIX FRANKFURTER. A distinguished attorney and criminal investigator, Felix Frankfurter (1882–1965) was appointed to the position of associate justice on the Supreme Court by Pres. Franklin D. Roosevelt in 1939; he served until his retirement in 1962. A liberal, he supported civil rights reform and was instrumental in the landmark 1954 *Brown v. Board of Education* decision, which barred racial segregation in American public schools. In his younger days, he had also been a strong Zionist and had also opposed the execution of Nicola Sacco and Bartolomeo Vanzetti. Frankfurter was born in Vienna, Austria, and came to the United States with his family in 1894.

VINCENT RICHARD IMPELLITTERI.
Another immigrant to serve as mayor of New York was Sicilian-born Vincent Richard Impellitteri (1900–1987). Brought to New York in 1901, he grew up in Connecticut. He received a law degree from Fordham University and served as an assistant district attorney in Manhattan. He was elected president of the city council and then mayor (1950–1953). After leaving office, he served as a criminal court judge.

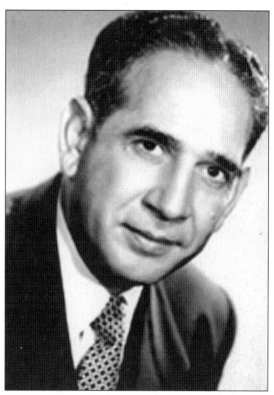

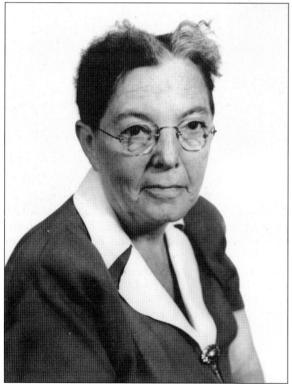

PAULINE NEWMAN. Labor organizer and strike leader Pauline Newman (1890–1986) was from Popelan, Kuvna, Lithuania. In 1901, she and her mother left Lithuania and immigrated to the United States to join two of the older Newman children in New York. They arrived at Ellis Island in May 1901 and went to live with relatives on the Lower East Side. For a time, Newman worked at the Triangle Shirtwaist Factory, but she was drawn to union organizing and eventually rose to become director of health education at the International Ladies Garment Workers Union.

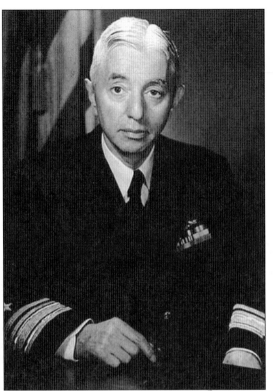

HYMAN G. RICKOVER. Known as the "father of the nuclear navy," Hyman G. Rickover had a distinguished naval career, attaining the rank of admiral. He served a record 63 years on active duty. He and his family immigrated through Ellis Island in 1904.

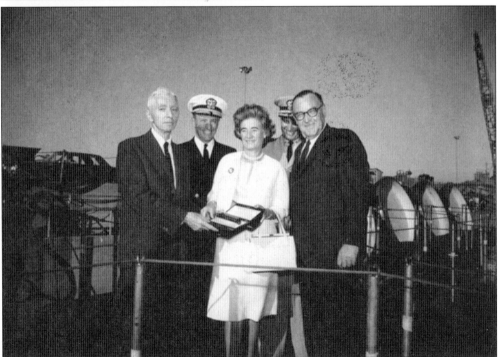

ADMIRAL RICKOVER. In 1964, Admiral Rickover received a citation from Gov. Edmund G. Brown of California. He is pictured here with the governor and his wife.

EDWARD CORSI. A lawyer, journalist, social worker, and public official, Edward Corsi (1896–1965) had a long career in the service of the public interest. Born in Capistrano, Italy, his family moved to New York in 1907. Corsi served as director of Harlem House in the Italian quarter, and his work there won him the appointment of federal commissioner of immigration for the port of New York (Ellis Island) from Pres. Herbert Hoover. He held this prestigious post from 1931 to 1934.

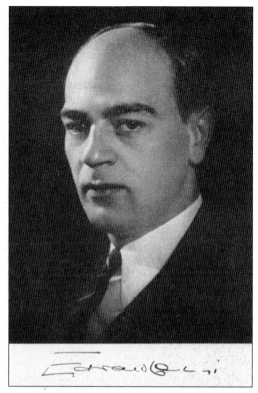

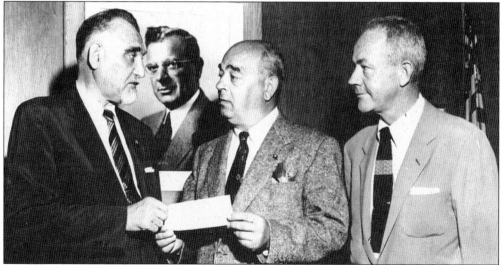

EDWARD CORSI AND THE AMERICAN MUSEUM OF IMMIGRATION. After unsuccessful bids for the Senate (1938) and mayor of New York City (1951), Corsi served in various positions under Gov. Thomas Dewey and U.S. Secretary of State John Foster Dulles. In this photograph (1956), he is accepting a donation of $5,000 from the Amalgamated Clothing Workers of America in his capacity as vice president of the American Museum of Immigration. A picture of the union's deceased leader, Sidney Hillman, seems to look on in approval. Both Corsi and Hillman were Ellis Island immigrants. The museum was eventually built in the base of the pedestal of the Statue of Liberty.

GEORGE CHRISTOPHER.
Springing from the working-class district of Greektown, George Christopher (1907–2000), the son of a cook, went from bookkeeper to millionaire dairyman to mayor of San Francisco (1956–1964) within a span of 20 years. Any greater political goals of his were cut short when conservative film star Ronald Reagan won the 1966 Republican gubernatorial primary by a landslide. Born in Arcadia, Greece, Christopher came to this country with his mother in 1911 to join his father in San Francisco. George Christopher was one of San Francisco's most popular mayors.

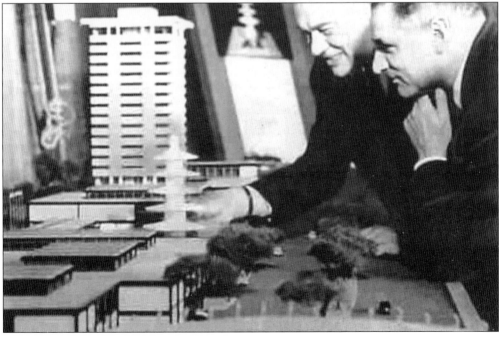

WILLIAM O'DWYER. Irish immigrant William O'Dwyer was the third Ellis Islander to serve as a New York City mayor. He went from his native county, Mayo, to study for the priesthood in Spain before he made a permanent detour to New York. There he became a policeman and by the aid of night school gained his law degree. After serving as a county judge in Brooklyn, he was elected the city's district attorney. In this post he successfully prosecuted the criminal organization known as Murder, Inc. and jailed its kingpin, Charles "Lucky" Luciano. With this triumph, he easily won reelection in 1941 and in 1945 was elected to succeed Fiorello LaGuardia as mayor. Although reelected in 1949, O'Dwyer fell from grace in a police corruption scandal and resigned from office in 1950. Pres. Harry S. Truman appointed him ambassador to Mexico, a post that he held for about a year.

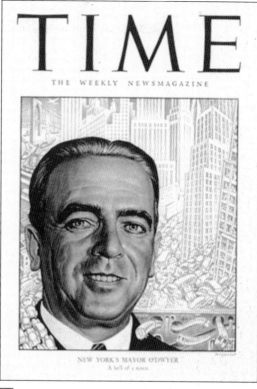

TIME

THE WEEKLY NEWSMAGAZINE

NEW YORK'S MAYOR O'DWYER
A hell of a town.

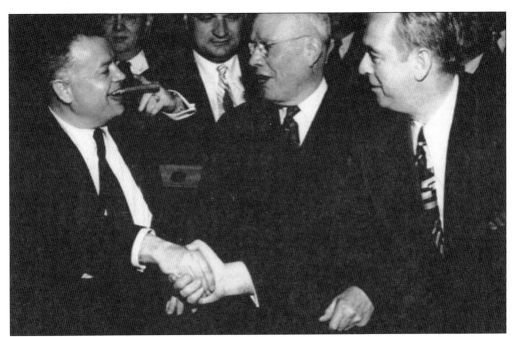

DAVID DUBINSKY AND MAYOR WILLIAM O'DWYER. The future labor leader David Dubinsky was born in Russia and worked as a baker before coming to New York in 1911. In America, Dubinsky (1892–1982) became a garment worker and soon became active in his trade organization, the International Ladies Garment Workers Union. He was a prominent official in the 1920s and served as its president from 1932 to 1966. The two Ellis Island immigrants David Dubinsky (left) and Mayor William O'Dwyer (right) are seen at a civic function.

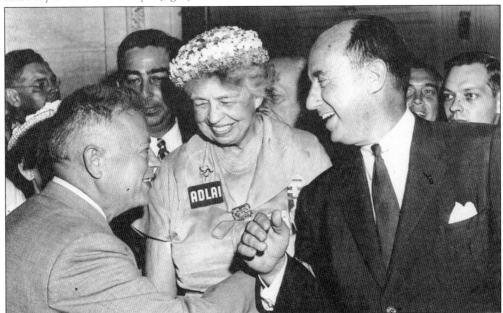

DUBINSKY, ELEANOR ROOSEVELT, AND ADLAI STEVENSON. Taken during Gov. Adlai Stevenson's campaign for the presidency, this picture shows two of his ardent supporters, Dubinsky and former first lady Eleanor Roosevelt, expressing their excitement over the campaign.

SIDNEY HILLMAN. Sidney Hillman (1887–1946) was the founder of the Amalgamated Clothing Workers of America and its president from 1914 to 1946. Hillman was a strong leader who sought to make reasonable compromises with business owners. He was a fervent supporter of Pres. Franklin D. Roosevelt and was also a friendly adviser. Hillman was born in Lithuania and came to the United States in 1907 to escape oppression.

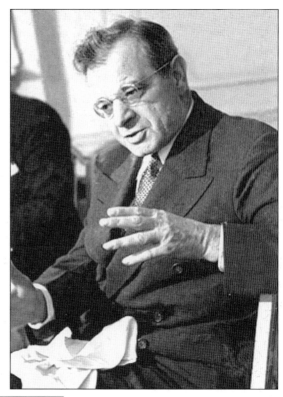

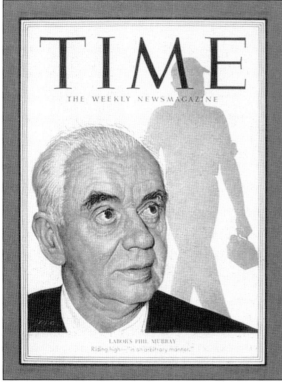

TIME
THE WEEKLY NEWSMAGAZINE

LABOR'S PHIL MURRAY
Riding high—"in an arbitrary manner."

PHILIP MURRAY. One of the most important union leaders of the first half of the 20th century was Philip Murray (1886–1952). A native of Blantyre, Scotland, he and his father came seeking work in the coal mines of Pennsylvania. Shocked by the unfair treatment by mine owners, he became active in the United Mine Workers and from there steadily rose until he attained the presidency of the Congress of Industrial Organizations (CIO).

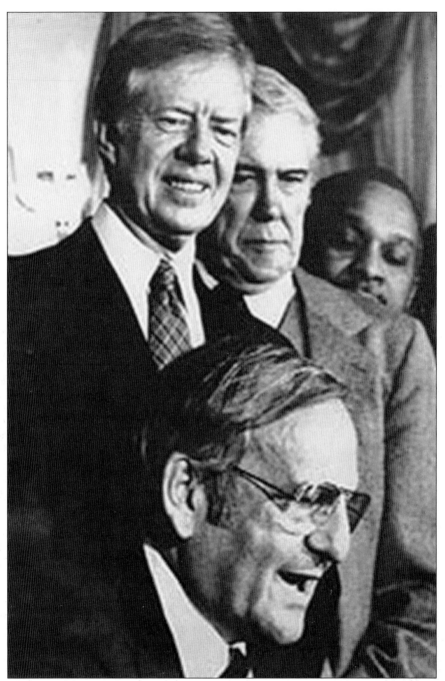

DOUGLAS FRASER. Another Scottish immigrant drawn into the leadership of a major trade union was Douglas Andrew Fraser. Born in Glasgow, Scotland, in 1916, Fraser was brought to America in 1923 by his mother aboard the SS *Cameronia;* they proceeded to Detroit where his father worked. When he was 18, he began working in the automobile industry and was soon active in his union. He climbed the ladder until he attained the presidency of the United Auto Workers (1977–1983). He is pictured with Pres. James Carter and Lee A. Iacocca, chairman of the Chrysler Corporation.

Five

ATHLETES AND ADVENTURERS

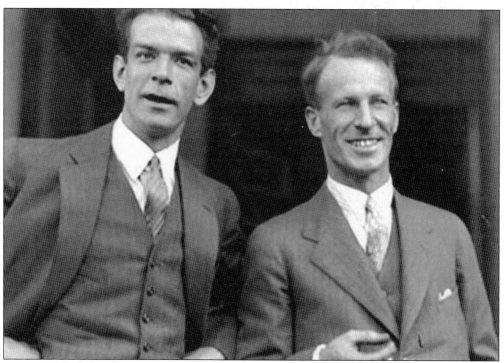

CHARLES KINGSFORD-SMITH. Quite unexpectedly, the great Australian aviator Sir Charles Kingsford-Smith (1897–1935) was at one time detained at Ellis Island. After being demobilized from the Royal Flying Corps at the end of World War I, he decided to try his luck in America. Traveling second class on the *Lorraine*, he contracted scarlet fever and was hospitalized at Ellis Island directly upon his arrival. Two weeks later, he recovered and was discharged. He lived in California for two or three years. Standing on the right, he is pictured with his friend, aviator Charles Ulm.

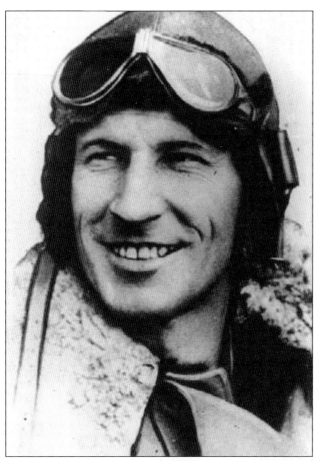

SIR CHARLES KINGSFORD-SMITH. The Australian aviator was the first to make a transpacific flight. In 1928, he and his relief pilot Charles Ulm flew from Oakland, California, to Brisbane, Queensland. For this triumph he was knighted by His Majesty King George V in 1932. In 1935, he and his crew were lost while flying from England to Australia. The airplane wreckage was found in Burma.

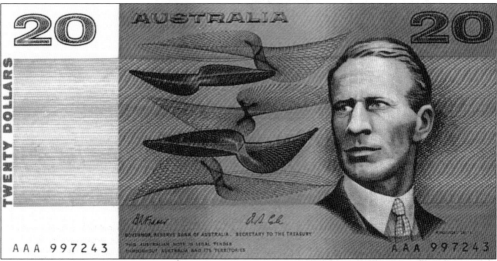

NATIONAL HERO. As a major Australian national hero, Kingsford-Smith is remembered in numerous ways in his homeland. Pictured is the $20 banknote that bore his face; it was in circulation from 1966 to 1994. In addition, Sydney's international airport is officially named Kingsford-Smith International Airport.

KNUTE ROCKNE. Among Ellis Island's many immigrants, few were better loved and admired than football great Knute Rockne (1888–1931). Born in Voss, Norway, he and his mother passed through Ellis Island in 1893 on their way to Chicago. Rockne attended Notre Dame University and stayed on to coach its football team for the rest of his life. His fame rests on his perfection of the forward pass and triumphant victories of the Fighting Irish.

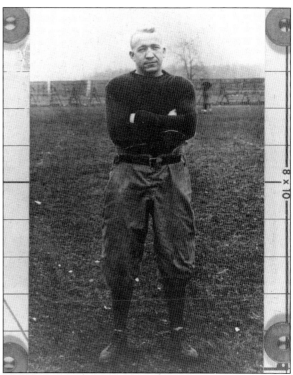

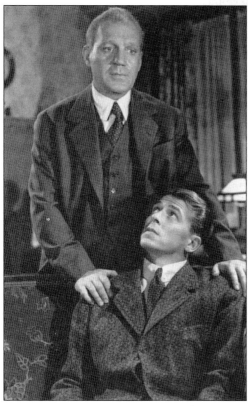

KNUTE ROCKNE–ALL AMERICAN. Ten years after he was killed in an airplane crash, Rockne's life was celebrated in the classic Warner Brothers film *Knute Rockne–All American.* The 1940 motion picture starred Pat O'Brien as Rockne and Ronald Reagan as George Gipp, his finest player.

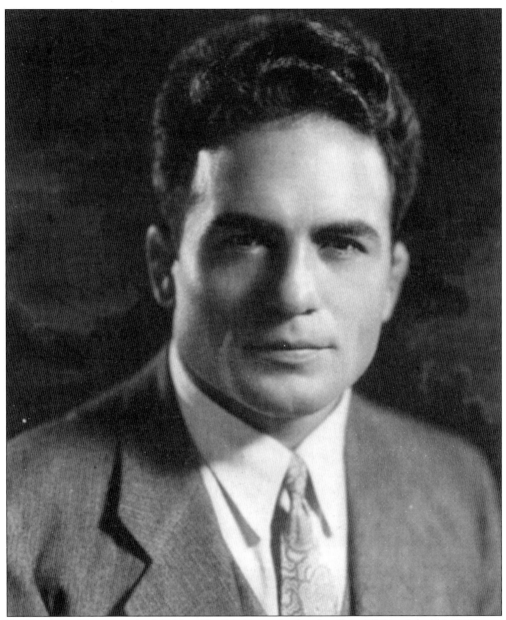

JIM LONDOS. Known as the "Golden Greek" during his heyday (late 1920s to around 1940) as a wrestler, Jim Londos (1895–1975) created excitement during his appearances as he proved that he was the undisputed master of wrestling. He was born Christos T. Theophilou in Koutsopodi, Argos, Greece. He immigrated to the United States in 1912. Among his fans, Greek immigrants were perhaps most enthusiastic.

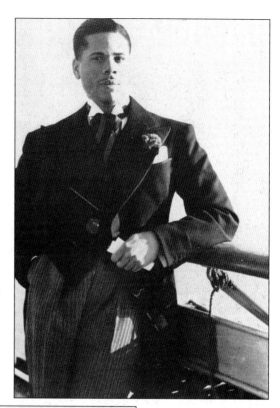

HUBERT FAUNTLEROY JULIAN. Known as the "Black Eagle of Harlem," Col. Hubert Fauntleroy Julian (1897–1983) dazzled admirers with his persistence, elegance, and successes. Born in Trinidad, Julian went to England during World War I, and there he experienced his first taste of flying. He immigrated to the United States in 1922 and made a successful transatlantic flight in 1929. His brief detention at Ellis Island came as a result of his giving assistance to Abyssinia during its 1936 war with Italy; he accepted Ethiopian citizenship, thus giving up his British nationality. In later years, he was an international arms dealer.

Harlem 'Black Eagle' Barred From Country; Visa of Julian, Now an Ethiopian, Faulty

Colonel Hubert Fauntleroy Julian, "Black Eagle of Harlem" and former pilot in the Ethiopian Army, was barred from the United States yesterday after a special inquiry board on Ellis Island had studied his case and found that he did not have proper papers.

Although he has appealed his case to the Department of State and asked for permission to enter the country temporarily if the appeal is lost, Colonel Julian may be refused admittance, in which case he will have to return either to France, whence he last came, to Ethiopia, where he is listed on the rolls as a citizen, or to his native Trinidad.

The debonair colonel has renounced Ethiopia, in a way. He returned from there a month or so ago, declaring that his stay in Africa had changed his opinion of his adopted country.

On his arrival he revealed that a wealthy woman in Port Said had given him a fund of $60,000 to support a lecture tour, on which he could tell the people of America what he really thought of the African trouble.

He sailed to France again ten days later without troubling to obtain re-entry papers, believing that the visa issued to him by the American consul in Addis Ababa was good for four months. But when he returned Wednesday on the French liner Champlain he was seen in long conversations with immigration inspectors, and finally told reporters that he had been detained.

Julian said on the Champlain that he was making preparations to die, as he was convinced that assassins would get him sooner or later; that he had already been attacked and had received many threats. He took one of his sons to France for schooling, and has paid for funeral expenses at a Harlem burial establishment.

The flier offered yesterday to post bond for a temporary visit here but this cannot be accepted until the State Department has passed on his appeal. He told immigration authorities that he wanted to become an American citizen, but to accomplish this he will now have to leave the country and apply for admission as an immigrant.

His family lives at 118 West 119th Street.

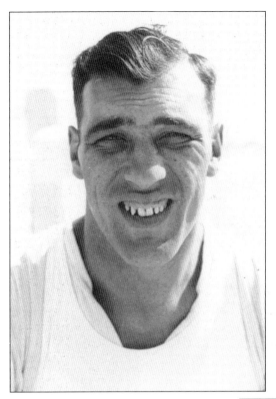

PRIMO CARNERA. The photograph at left of champion Primo Carnera (1905–1967) was taken in 1934 at his training camp in Florida as he prepared to fight Tommy Loughran (whom he defeated). A native of Sequals, Italy, the six-foot-five-inch Carnera began his professional boxing career in France. By 1930, he had established himself in Europe and came to the United States. His fighting was largely successful, especially when he won the world heavyweight championship by defeating Jack Sharkey in 1933. But one year later, Carnera lost the title to Max Baer. Carnera remained a major contender in the ring until ill health forced his retirement in 1938. In later years, he became a popular wrestler; he became a U.S. citizen in 1953.

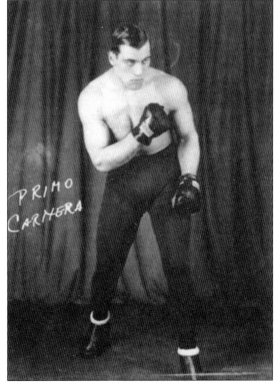

Primo Carnera at Ellis Island. In 1930, Carnera found himself in some difficulties when the Bureau of Immigration declined his request for an extension of his visa. This forced him to go to Ellis Island to make his appeal, but he was quickly redirected to the Department of Labor in Washington, where at last he got his extension request granted.

Jack Doyle. Ireland's famous singing boxer Jack Doyle (1913–1978), known as the "Gorgeous Gael," had many difficulties and considerable fun during his time in the United States (1935–1938). The prizefighter had his ups and downs in the ring, in his love life, and finally, with immigration authorities. He was only briefly at Ellis Island and that was to collect a renewed visa in 1937. The next year, he ran afoul of immigration and left for good.

Former Boxing Champion Held

Alphonse Brown, 29 years old, of 55 West 110th Street, who under the name of Panama Al Brown was bantamweight boxing champion of the world a few years ago, was arrested yesterday by Detectives Aristides Ramos and Louis Muscatel of the police criminal alien squad on a Federal immigration warrant. He was turned over to authorities on Ellis Island. The former boxer came to the United States from France last March with a visa permitting residence here until last September.

PANAMA AL BROWN. The first Latin American to hold boxing's world bantamweight championship title, Alfonso Brown (1902–1951) was born in Colon, Panama; he held the world championship from 1929 to 1935. According to a *New York Times* story from 1938, "Panama Al" had stayed in the country after his visa expired and this resulted in his detention at Ellis Island. In 1992, he was inducted into the International Boxing Hall of Fame.

Six

MUSICAL AND THEATRICAL ICONS

GUS KAHN. A top Tin Pan Alley lyricist, Gustav Gerson Kahn (1886–1941) was born in Cologne, Germany, and emigrated with his family in 1892; they settled in Chicago. Kahn wrote songs for vaudeville and films. His greatest hits include "I'll See You in My Dreams," "It Had to Be You," "Yes, Sir, That's My Baby," "Love Me or Leave Me," "Carolina in the Morning," and "Dream a Little Dream of Me." In the picture, he is the one with the pipe in his mouth.

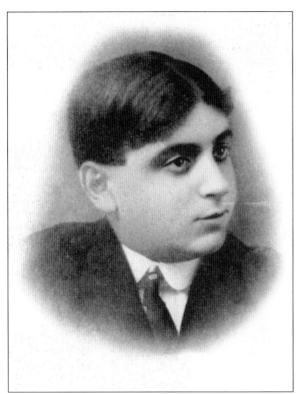

IRVING BERLIN. Truly an institution in the world of popular music, Irving Berlin (1888–1989) came to this country from Russia in September 1893; his original name was Israel Beilin, and he grew up on Manhattan's Lower East Side. Berlin started out as a lyricist but eventually wrote the words and music to all of his compositions. From Tin Pan Alley and vaudeville, he conquered Broadway and Hollywood.

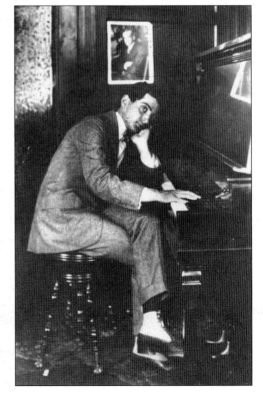

"I LOVE A PIANO." As a boy, Berlin fell in love with music and drifted to Tin Pan Alley, where he composed his first hit songs for vaudeville and Broadway. Among them are unforgettable classics like "Alexander's Ragtime Band," "Play a Simple Melody," "When I Lost You," "I Love a Piano," and "A Pretty Girl is Like a Melody." In the 1920s, he scored with "Say It with Music," "Always," "What'll I Do?," and "Blue Skies."

AMERICA'S ENDURING FAVORITE. During the Great Depression, Berlin proved his resilience and his relevance to a new generation. He clicked with "How Deep Is the Ocean?," "Say It Isn't So," "God Bless America," "White Christmas," and "Easter Parade." He is seen in his 1942 movie musical, *This is the Army*, in which he sang "Oh, How I Hate to Get Up in the Morning."

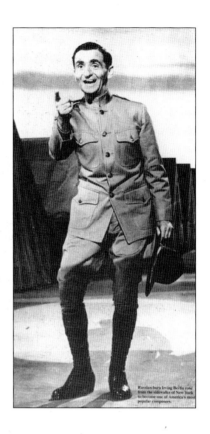

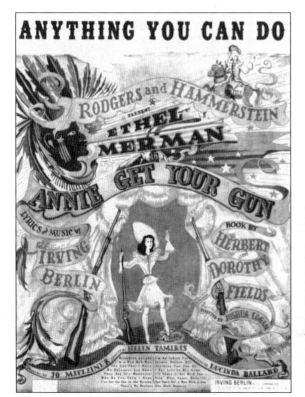

LATER SHOWS. Berlin's greatest Broadway success was the musical *Annie Get Your Gun* (1946), which starred Ethel Merman The rare charm of such songs as "Doin' What Comes Naturally," "Moonshine Lullaby," "I Got Lost in His Arms," "The Girl That I Marry," and "There's No Business Like Show Business" dazzled audiences. *Miss Liberty* (1949) was a minor hit, as was *Call Me Madam* (1950). Berlin retired in 1962 and died at the age of 101 in 1989.

61

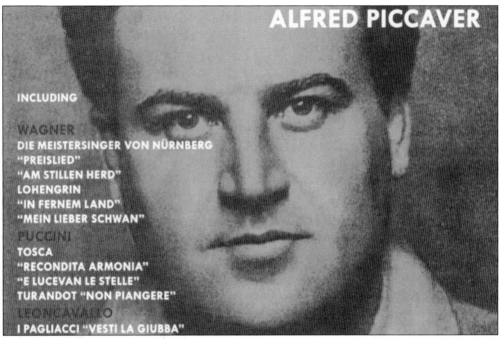

ALFRED PICCAVER

INCLUDING

WAGNER
DIE MEISTERSINGER VON NÜRNBERG
"PREISLIED"
"AM STILLEN HERD"
LOHENGRIN
"IN FERNEM LAND"
"MEIN LIEBER SCHWAN"
PUCCINI
TOSCA
"RECONDITA ARMONIA"
"E LUCEVAN LE STELLE"
TURANDOT "NON PIANGERE"
LEONCAVALLO
I PAGLIACCI "VESTI LA GIUBBA"

ALFRED PICCAVER. One of European opera's favorite tenors, Alfred Piccaver was born in Lincolnshire, England, and came to America in the steerage of the SS *Paris* in 1895. His talent was discovered when he was a teenager, and in 1907, he returned to Europe to study voice. His career took off, and he enjoyed extensive triumphs and acclaim. He died in Vienna. Pictured is one of the many CDs containing his best recordings.

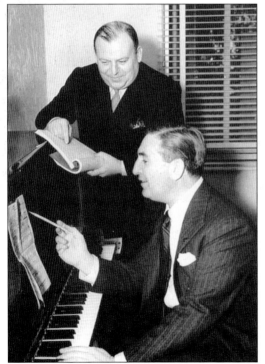

AL DUBIN. Another of Tin Pan Alley's lyricists was the incomparable Alexander Dubin (1891–1945). Born to Russian Jewish parents in Switzerland, he came to America in 1893 and settled in Philadelphia. His hits include "Among My Souvenirs," "We're in the Money," "A Cup of Coffee, a Sandwich and You," "Lullaby of Broadway," and "I'll Sing You a Thousand Love Songs." He is pictured (standing) with his partner, composer Harry Warren.

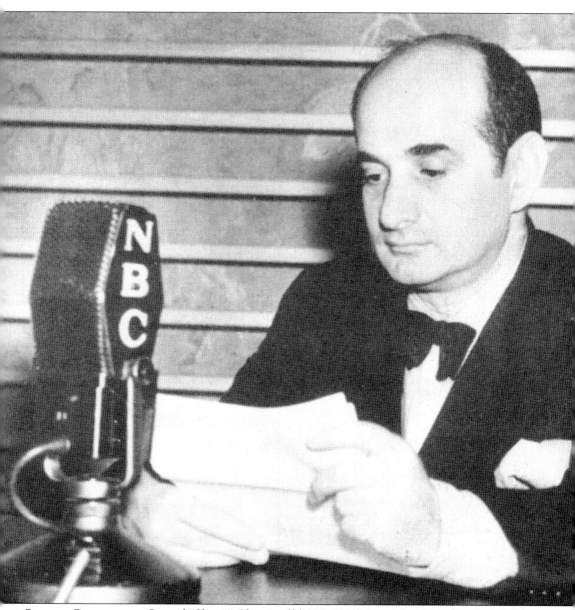

SAMUEL CHOTZINOFF. Samuel "Shotzi" Chotzinoff (1889–1964) is another example of poverty reaching for the stars and winning through. His family left Vitebsk, Russia, for the Lower East Side in 1905. A pianist and critic, he made a national reputation as music director of the NBC Symphony Orchestra (1936–1954) and produced NBC's televised operas. A confidante of Arturo Toscanini's and brother-in-law of Jascha Heifetz, Chotzinoff wrote two autobiographies, *A Lost Paradise* and *Day's at the Morn*.

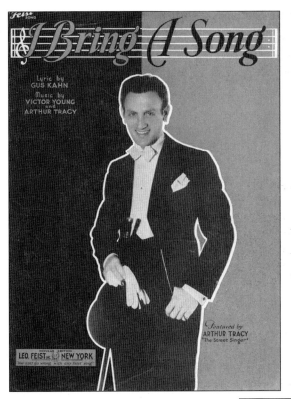

ARTHUR TRACY. Like many Jews in the Russia of 1905, the Tracavutskys suffered persecution and poverty. Sick of the life, they left for America in 1906. They changed their name to Tracy after leaving Ellis Island for Philadelphia, and Abba became Arthur Tracy (1899–1997). Influenced by the recordings of Enrico Caruso, Arthur became a singer and went into vaudeville in 1917. Fame came to him when he achieved stardom on radio in 1931.

THE STREET SINGER. With a romantic air and calling himself "the Street Singer," Tracy offered the public beautiful ballads in his elegant tenor baritone and became a sensation. Bookings poured in from vaudeville, and he costarred in Hollywood's *The Big Broadcast* (1932). Millions tuned in to his radio show to listen to him sing "Marta," "Smoke Gets in Your Eyes," "I'll Sing You a Thousand Loves Songs," and "Everything I Have Is Yours."

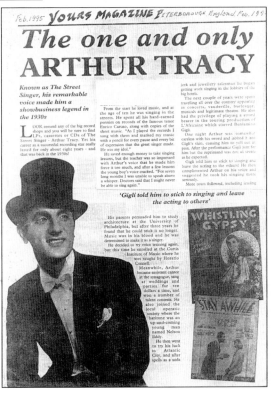

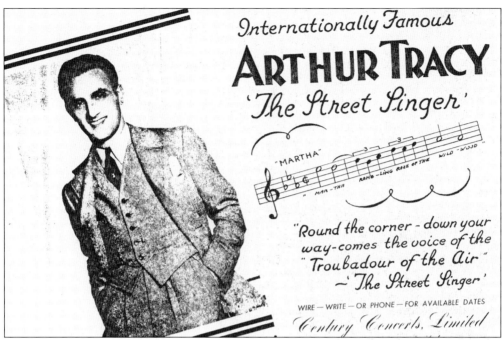

To England. In 1935, Tracy went to England for a seven-week engagement and wound up staying seven years! The British embraced him as one of their own, and he became a top stage attraction, radio artist, and film star. Songs such as "Pennies from Heaven," "Trees," "Red Sails in the Sunset," "September in the Rain," "The Whistling Waltz," and "A Sailboat in the Moonlight" kept him in their hearts.

Later Years. Tracy returned to the United States during the war and was given a new radio show on NBC. He performed in vaudeville for Loews, but his popularity declined with the rise of swing music; he retired in 1950. Meanwhile, he made a fortune in real estate. He made a comeback in the 1980s, charming old fans and young people alike. In 1996, he was awarded the Ellis Island Medal of Honor.

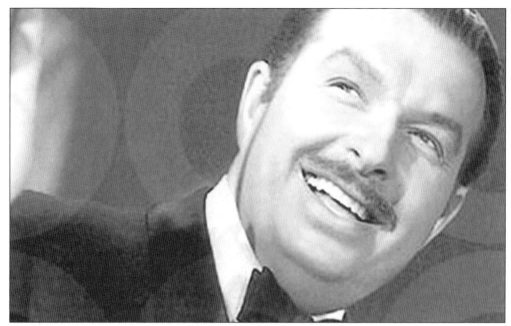

XAVIER CUGAT. From Barcelona, Spain, the Cugats moved to Cuba, where Xavier grew up, and then came to New York on the SS *Havana* in 1915. Xavier Cugat (1900–1990) popularized Latin music as a major bandleader in the 1930s, 1940s, 1950s, and 1960s. His orchestra was the featured band at the Waldorf Astoria Hotel, and it performed in Hollywood movies. He was dubbed the "Rumba King." He died in his native Catalonia.

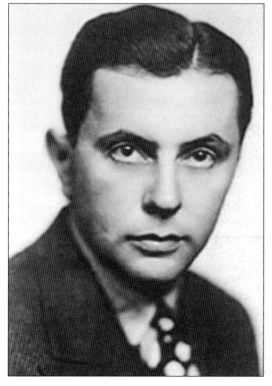

VERNON DUKE. Accomplished musician Vernon Duke composed both classical and popular music. Vladimir Dukelsky (1903–1969) was born in Russia. Because of the rise of bolshevism in Russia, he and his mother fled to Odessa and, from there, booked steerage passage on the *King Alexander* in Constantinople in 1921. Duke's hit songs include "April in Paris," "Autumn in New York," and "Taking a Chance on Love."

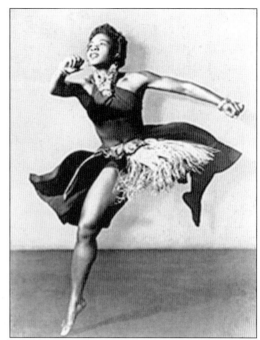

PEARL PRIMUS. A native of Port of Spain, Trinidad, Pearl Primus (1919–1994) came to Manhattan aboard the SS *Voltaire*. She, her mother, and her brother were discharged from Ellis Island to her father, who had come to fetch them. Famous for her leaping dance technique, she employed art as a means to promote social change and, further, her New Dance troupe and Earth Theatre were expressly intended to press for political reform.

DICK HAYMES. To his adoring fans, pop singer Dick Haymes (1918–1980) seemed a typical American; who would have guessed he was from Argentina? In 1937, he settled in Manhattan. His effort to become a songwriter flopped, but his voice clicked and in 1940 bandleader Harry James tapped him to replace Frank Sinatra. Soon World War II brought trouble for the foreigner, and his application for a draft exemption resulted in brief detentions at Ellis Island.

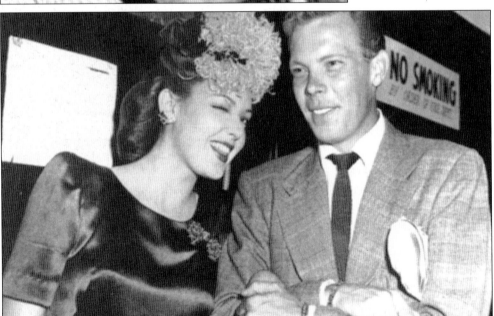

SCREEN STAR. Haymes's hit songs include "It's Magic," "You'll Never Know," "Long Ago and Far Away," "Laura," "The More I See You," "It Might as Well Be Spring," and "I'll Get By." His best films include *State Fair*, *The Shocking Miss Pilgrim*, and *St. Benny the Dip*. Linda Darnell's wink back in 1944 indicates what a heartthrob Haymes was. In the end, his six marriages and drinking ruined a great career.

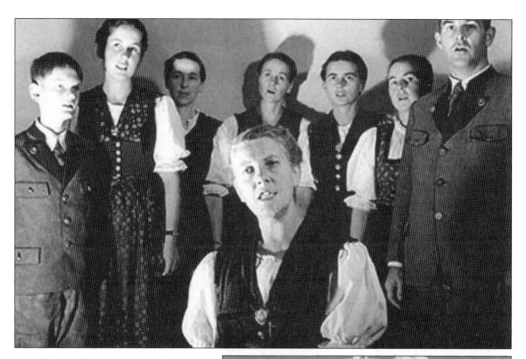

THE TRAPP FAMILY SINGERS. In 1938, the choral group the Trapp Family came from Austria and was promptly detained at Ellis Island. They settled necessary bureaucratic matters connected with their sudden immigration. In America, they enchanted audiences with their exquisite renditions of German songs from old Austria.

Ezio Pinza Seized as Enemy Alien; FBI Takes Singer to Ellis Island

Foxworth Silent on Detention of Italian-Born Opera Star, Understood to Have Taken Out His First U. S. Papers

Ezio Pinza, Metropolitan Opera basso, has been detained by the Federal Bureau of Investigation and taken to Ellis Island, it was learned yesterday.

P. E. Foxworth, assistant director of the bureau in charge of the New York district, would neither confirm nor deny Mr. Pinza's detention, but the fact was substantiated.

Neither Edward Johnson, manager of the opera, nor Edward Ziegler, his assistant, was available at the opera house for comment last night during the performance of "Pagliacci" and "The Island God." But it was said there that Mr. Pinza's next scheduled role was in tomorrow's matinee of "Faust," and that he was not due to sing yesterday.

Persons reached at the opera house had not heard of the incident. In fact, one of them said: "He was in here only yesterday afternoon."

Mr. Pinza, an Italian by birth, was understood to have taken out his first American citizenship papers. He had been in poor health

Ezio Pinza
The New York Times Studio

at times last month and had to cancel an appearance with Dusolina Giannini in a joint recital at Carnegie Hall.

Following his appearance tomor-

Continued on Page Ten

EZIO PINZA. One of opera's great baritones, Ezio Pinza (1892–1957) is remembered for his robust interpretations of *Don Giovanni* and *Boris Godunov*, as well as his screen success in *South Pacific* (1949) and unforgettable rendition of "Some Enchanted Evening." The Italian, a native of Rome, came to New York in the 1920s and dominated the Metropolitan Opera from 1926 to 1948, when he embarked on a new career in Hollywood.

CHARLES TRENET. French singing star Charles Trenet (1913–2001) was held at Ellis Island quite mysteriously for many weeks when he came for an engagement in 1948. Very probably it was caused by the heightened obsession with fascist collaboration, but it may have been his homosexuality. A great star, Trenet was dubbed the "Sinatra of France."

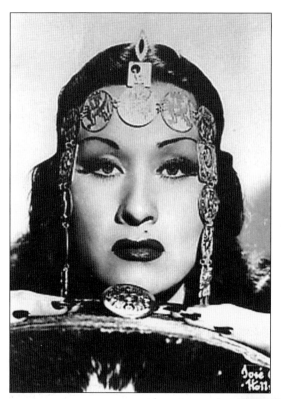

YMA SUMAC. Great Peruvian coloratura singer Yma Sumac was briefly detained at Ellis Island in July 1954 on suspicion of subversion. She expressed her mystification for the detention. Sumac (born in 1922) is celebrated for her near-five-octave range and her ability to recall through song the ancient Inca civilization, as well as the sounds of nature in her native Peru.

Seven

HOLLYWOOD STARS AND CELEBRITIES

ANTONIO MORENO. One of the leading romantic matinee idols of the silent era, Antonio Moreno (1887–1967) arrived at Ellis Island in 1902 under his original name, Antonio Garride Monteagudo. In 1924, he recalled his first glimpse of the Statue of Liberty: "I thought then that the placing of that goddess in the harbor was of divine inspiration, for to so many lonely hearts and fainting spirits it has been the symbol of welcome and hope." The Spaniard's films include *The Temptress* (with Greta Garbo), *It* (with Clara Bow), *The Spanish Dancer* (with Pola Negri), and *Mare Nostrum*, a spy thriller with Alice Terry. Above, he is pictured with Gloria Swanson in a scene from *My American Wife* (1922). With the coming of talking pictures, his heavy Castilian accent prevented his playing non-Latin roles convincingly, so he took starring roles in Spanish-language films made in Hollywood. In the 1940s and 1950s, he played character parts in mainstream productions, such as *The Searchers* (1956). He died in his Beverly Hills home.

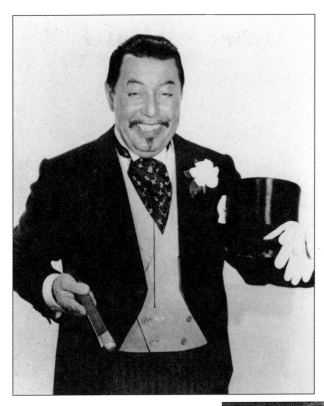

WARNER OLAND. Hollywood's most popular Charlie Chan was played by Swedish immigrant Warner Oland (1879–1938). Oland had a long and successful career in silent and talking pictures, and his credits include *The Jazz Singer* and *Shanghai Express*, as well as 16 Charlie Chan films. He came to the United States with his parents in 1893.

AL JOLSON. The first Jewish actor to achieve widespread fame and popularity, Al Jolson (1886–1950) came to Ellis Island in 1894 with his family; his original name was Asa Yoelson. He grew up in Washington, D.C., and went into vaudeville. By 1909, he had achieved stardom on Broadway and also became a recording artist. His greatest success was his starring role in *The Jazz Singer* (1927), the first talking picture.

THE SINGING FOOL. Al Jolson was indisputably the biggest singing star of the Roaring Twenties. When he recorded a song, it was a guaranteed hit. His most popular songs include "Swanee," "Avalon," "Rockabye Your Baby with a Dixie Melody," "California, Here I Come," "My Mammy," "April Showers," "Toot, Toot, Tootsie, Goodbye," and "Sonny Boy." The sheet music cover at right was for songs from his second sound feature, *The Singing Fool*.

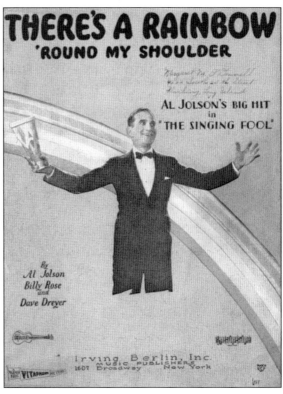

THE WORLD'S GREATEST ENTERTAINER. After several more films, Jolson's popularity as a Hollywood favorite declined. However, after World War II, Columbia Pictures released *The Jolson Story* (1946). This movie biopic was a sensation, and Jolson was famous all over again. He was everywhere: radio, stage, and recording studio. A sequel, *Jolson Sings Again*, was an even bigger hit. Both starred Larry Parks with vocals provided by Jolson himself.

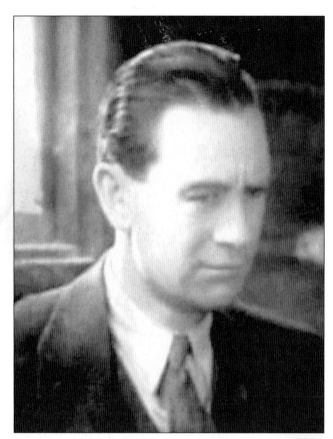

Owen Moore and Brothers. The three brothers Owen, Tom, and Matthew Moore were popular silent film actors from the second decade of the 20th century through the 1920s. Natives of Fordstown Crossroads, County Meath, Ireland, they came to the United States in May 1896 on board the *Anchoria* with their parents and three other siblings; they settled in Ohio. Interestingly, Matthew Moore's first film was *Traffic in Souls*, which dealt with white slavery and Ellis Island immigrants.

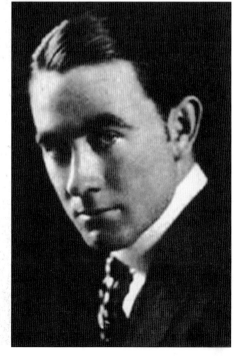

Owen Moore. Silent film star Owen Moore (1886–1939) met his first wife, Mary Pickford, while performing with her in D. W. Griffith's *The Lonely Villa* (1909). The two married in 1911 and divorced in 1920. His other silent films include *Cinderella* (1915, with Mary Pickford), *The Desperate Hero, Modern Matrimony,* and *Piccadilly Jim*; the last of his 279 movies was *A Star Is Born* (1937). His early death was caused by chronic alcoholism.

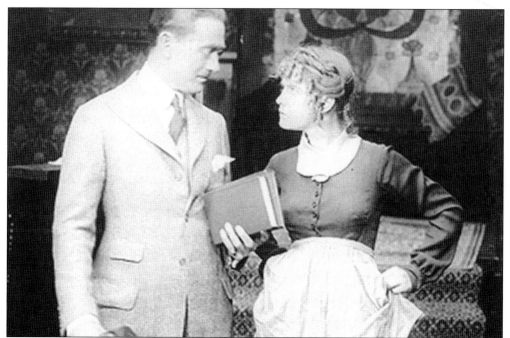

OWEN MOORE AND DOROTHY GISH. One of Owen Moore's many leading ladies was Dorothy Gish. They appeared together as the principals in *Little Meena's Romance* (1916), in which Gish portrayed a Pennsylvania Dutch heiress and Moore a German count. Moore's other leading ladies include Marion Davies, Gloria Swanson, Joan Crawford, Constance Bennett, Leatrice Joy, and, of course, his wives, Mary Pickford and Katherine Perry.

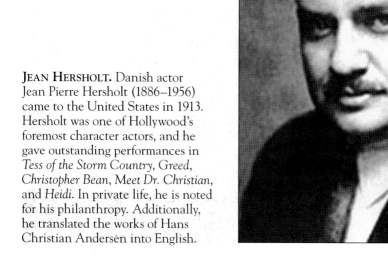

JEAN HERSHOLT. Danish actor Jean Pierre Hersholt (1886–1956) came to the United States in 1913. Hersholt was one of Hollywood's foremost character actors, and he gave outstanding performances in *Tess of the Storm Country, Greed, Christopher Bean, Meet Dr. Christian,* and *Heidi.* In private life, he is noted for his philanthropy. Additionally, he translated the works of Hans Christian Andersen into English.

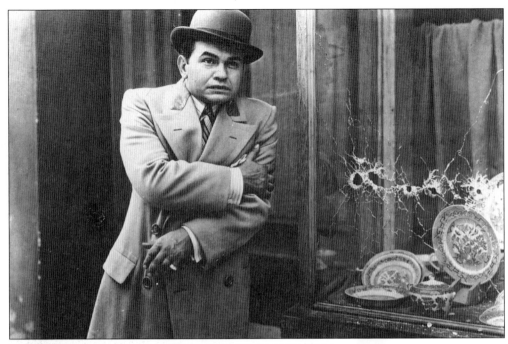

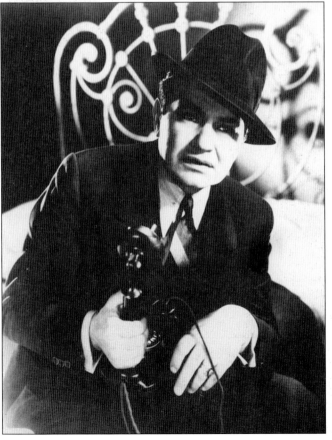

EDWARD G. ROBINSON.
One of Hollywood's most memorable stars, Edward G. Robinson (1893–1973) emigrated from Romania as Emmanuel Goldenberg in 1903; the family settled in lower Manhattan. Attracted to drama, Robinson became a stage actor, and at the advent of talking pictures, Warner Brothers offered him a contract and put him in crime melodramas, including *Little Caesar, Smart Money, The Little Giant,* and *Key Largo.* His versatility can be seen in *Dr. Ehrlich's Magic Bullet, Scarlet Street, Double Indemnity,* and *A Dispatch from Reuters.*

IRÈNE BORDONI. Irène Bordoni's rise to theatrical acclaim was meteoric. Bordoni (1885–1953), known for her French coquettish manner and winking eye, came to America at age 22 on the *Provence*, in steerage, in December 1907. The Corsican went to her Italian father, Antonio, in Nevada. But the limelight soon beckoned. Her shows include *Hitchy-Koo*, *The French Doll*, *Naughty Cinderella*, *Paris*, and *Louisiana Purchase*. She married songwriter E. Ray Goetz.

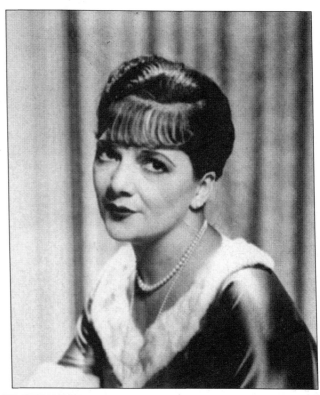

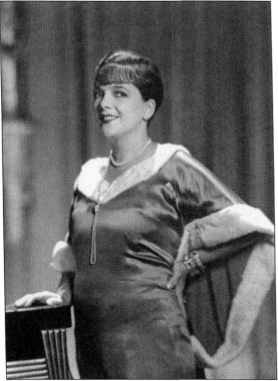

IRÈNE BORDONI IN PICTURES. Although her fame rests on her Broadway and vaudeville triumphs, Irène Bordoni also made a number of interesting films. For Americans of later generations, her delightful performance as Madame Bordelaise in *Louisiana Purchase* (1941) is her most cited performance. Her other films are *Paris* (with Jack Buchanan) and the vaudeville picture *The Show of Shows*. She also starred in a string of silent films for Pathé in France.

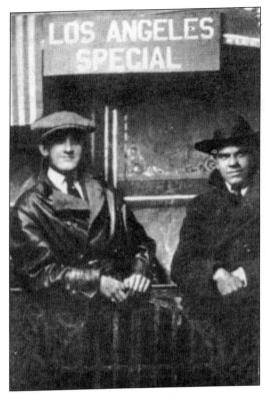

FRANK CAPRA. Academy Award–winning movie director Frank Capra (1897–1991) was born in Sicily as Francesco Capra. His family traveled in steerage on the *Germania* in 1903; from Ellis Island, they went to Los Angeles. Determined to get somewhere, Capra broke family tradition and went to college. He bluffed his way into the film industry and became a top director in the 1930s. His films include *The Strong Man, Ladies of Leisure, It Happened One Night, Lost Horizon, You Can't Take It with You,* and *Arsenic and Old Lace.*

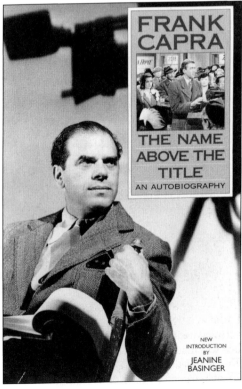

JOHNNY WEISSMULLER. Hollywood's most famous Tarzan was Austrian immigrant Johann "Johnny" Peter Weissmuller (1904–1984). He came with his parents in steerage on the SS *Rotterdam* in 1905; he was seven months old. Johnny was an outstanding athlete and gained international acclaim as an Olympic swimming champion. He won five gold medals at the 1924 and 1926 Olympics.

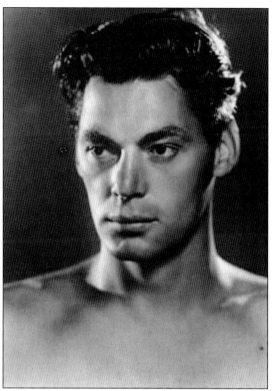

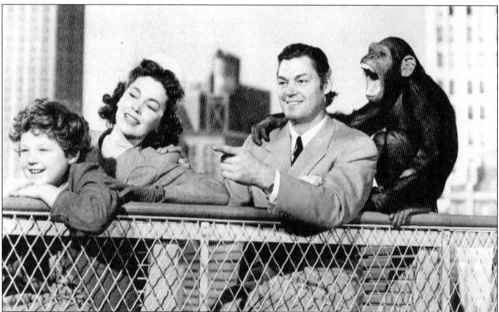

FROM ATHLETE TO MOVIE STAR. In 1932, Weissmuller starred in *Tarzan the Ape Man*, and his acting career was sealed. A string of Tarzan films followed, including *Tarzan and His Mate*. The last was made in 1948, and the actor took on another film hero, Jungle Jim. Here is a scene from *Tarzan's New York Adventure* (1942). Who knows, maybe Cheeta the Liberian chimpanzee, now 75, also passed through Ellis Island.

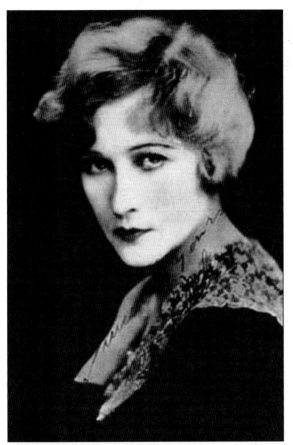

ANNA Q. NILSSON. Before Greta Garbo, America's first Swedish film star was Anna Quirentia Nilsson (1888–1974). She arrived in 1905, became a model, and in 1911, a film actress. Her credits include *Over There, Ravished Armenia, Her Kingdom of Dreams, The Spoilers,* and *One Way Street.* Years later, the former star appeared with Buster Keaton and H. B. Warner as one of Norma Desmond's has-been star friends—the waxworks—in *Sunset Boulevard.* Below, she is pictured (center) with Norma Talmadge (right) and Alice Joyce.

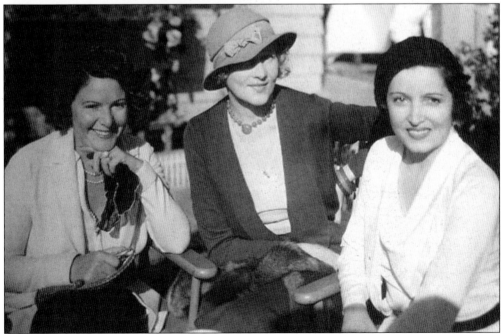

LESLIE FENTON. Born in Liverpool, England, Leslie Fenton (1903–1978) achieved a measure of acclaim as an actor in silent and talking pictures. His film credits include *East Lynne*, *What Price Glory*, *The Public Enemy*, *The Casino Murder Case*, *House of Secrets*, and *Boys Town*. In the 1940s, he directed such films as *Saigon*, *Lulu Belle*, *Whispering Smith*, *Streets of Laredo*, and *The Redhead and the Cowboy*. His wife was actress Ann Dvorak.

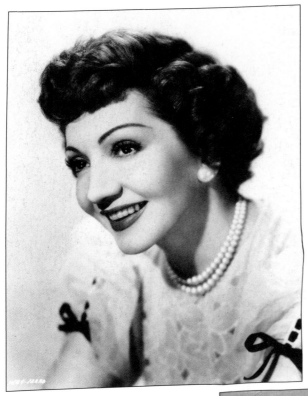

CLAUDETTE COLBERT. The Academy Award–winning actress Claudette Colbert was born in Paris and came to the United States as Lily Chauchoin with her mother in 1906; according to immigration records, her father, Georges, was a cook. Colbert (1903–1996) was one of Hollywood's principal leading ladies for years. Her film credits include *The Sign of the Cross, Cleopatra, It Happened One Night, Boom Town, The Palm Beach Story, Since You Went Away, The Egg and I,* and *Let's Make It Legal.* She was also popular on the stage and on television. She died in Barbados.

DONALD CRISP. Actor Donald Crisp (1881–1974), who arrived on the *Campania* on May 7, 1909, was briefly detained because he had only $4. This must have been one of the few times that the Scot was seriously short of funds. Crisp was born in London, and his British origins defined the characters he played, particularly in sound films. His credits include *The Birth of a Nation*, *Broken Blossoms*, *National Velvet*, and *How Green Was My Valley*.

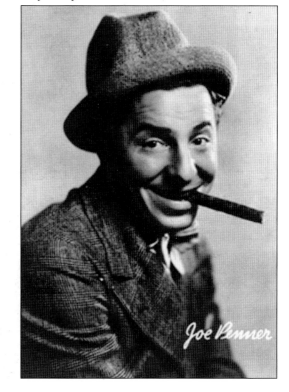

JOE PENNER. The zany vaudeville and radio comedian whose catchphrase, "Wanna buy a duck?," followed by a low foolish chuckle was none other than Joe Penner (1904–1941), a Hungarian immigrant. In May 1907, Josef Pinter traveled to America on the *Slavonia* with his guardian; they were briefly detained at Ellis Island. Penner's films include *College Rhythm*, *The Day the Bookies Wept*, and *The Boys from Syracuse*.

BOB HOPE. The Hope family was from Eltham in Kent and left England on the SS *Philadelphia*; they were inspected at Ellis Island on March 30, 1908. The Hopes settled in Ohio, and Bob, whose original name was Leslie, tried his hand at boxing as a youth (his nifty name was "Packy East"), but he found his real talent lay in the theater. Vaudeville was his choice, and he cut a neat figure in the vaudeville circuits through the 1920s. Stardom came by way of Broadway (as he had been hoping), and he received mostly glowing reviews for his performances in *Smiles, Roberta, Say When, The Ziegfeld Follies of 1936*, and *Red, Hot and Blue*. Having climbed out of vaudeville (at last) and finding himself a Broadway star, he was now hoping to make a splash in a place beyond New York, and that place was Hollywood.

THANKS FOR THE MEMORY. Bob Hope (1903–2003) became a star on radio, an excellent medium for gaining national name recognition. He was an immediate hit on the airwaves, and film offers followed. Hope's performance in *The Big Broadcast of 1938*, the film in which he introduced his Oscar-winning theme song, "Thanks for the Memory," was well received, and he soon became a major box office attraction. He delighted millions in *The Cat and the Canary, Road to Singapore, The Ghost Breakers, Caught in the Draft, Louisiana Purchase, They Got Me Covered, The Paleface, Sorrowful Jones, The Lemon Drop Kid*, and many others. Hope also became a major television star and continued broadcasting an annual Christmas special up until his 90th year. He garnered many major honors in his last years. In 1998, he was knighted by both Her Majesty Queen Elizabeth II and His Holiness Pope John Paul II. The Burbank airport was renamed Bob Hope Airport. He lived to be 100.

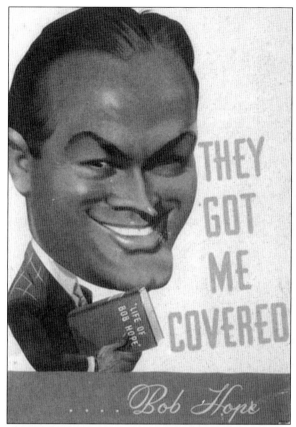

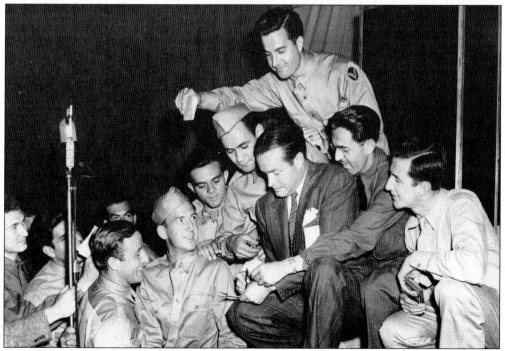

MIKE MAZURKI. A wrestler turned actor, Mike Mazurki (1909–1990) was born in Tarnopol, Galicia, Austria-Hungary, and emigrated with his family in 1914. His original name was Mikhail Muzurwski. The six-foot-six-inch actor often played physically menacing roles. His screen credits include *Murder My Sweet*, *Nightmare Alley*, *Night and the City*, and *The Harder They Fall*.

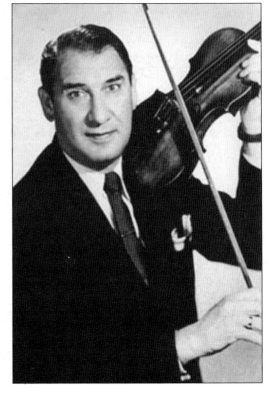

HENRY YOUNGMAN. Another English-born comedian, Henry Youngman (1906–1998) left on the SS *Cedric* when only an infant; he grew up in Brooklyn, New York. Famous for his one-liners, he performed in vaudeville, burlesque, and nightclubs; in later years, he was a regular on television. He also played the violin as a part of the act.

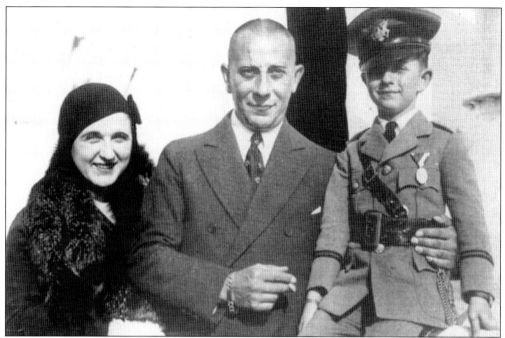

ERICH VON STROHEIM. Glorious memories of the imperial Hapsburg Monarchy were engraved in Erich von Stroheim's imagination when he came to Hollywood. He re-created a version of its lofty elegance in *The Merry Widow* and *The Wedding March*. Although touching on other themes, many of his other films show the same influence. Among them are *Greed*, *Foolish Wives*, *Three Faces East*, *The Devil's Pass Key*, and *Blind Husbands*. Von Stroheim (1885–1957) was born in Austria and sailed for New York in less-than-stylish steerage class on the liner *Prinz Friedrich Wilhelm* in November 1909.

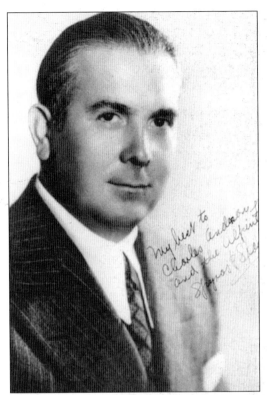

SPYROS SKOURAS. Greek immigrant Spyros Skouras was one of the most formidable executives in Hollywood as head of Twentieth Century Fox studios (1942–1962). During his reign, he saved the movie industry from its rival, television, by introducing Cinemascope. Skouras (1893–1971) was a shepherd in the old country, but in 1910, he bought a steerage ticket to America on the SS *Athinai*. He came with two devoted brothers, and they went to St. Louis.

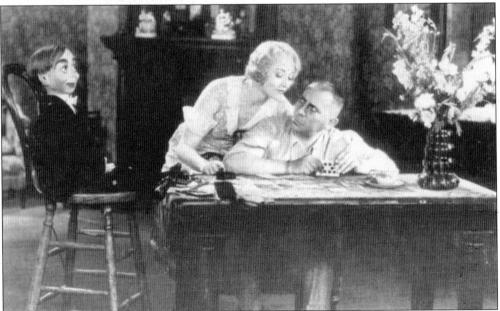

THE GREAT GABBO. In the 1929 talking picture *The Great Gabbo*, Erich von Stroheim portrays an egotistical ventriloquist who performs in vaudeville with his long-suffering wife, portrayed by the fine actress Betty Compson. At last, his wife can take no more of his abuse and leaves Gabbo. But with his curiously powerful dummy, Otto, he rises to Broadway fame. The end is a doleful one, even tragic, as he goes mad wandering the streets.

ELIA KAZAN. This great Greek American film director Elia Kazan (1909–2003) was born in Constantinople and was brought to New York in 1913. Although his original name is said to have been Elias Kazanjoglou, in the list of steerage passengers on the *Kaiser Wilhelm der Grosse* he is simply listed as Elia Kazan. After a brief stint at acting, Kazan became a film director, and his abilities soon placed him in the ranks of the best in his field. His credits include *Gentlemen's Agreement* and *On the Waterfront*, for which he won Academy Awards, and *A Streetcar Named Desire*, *East of Eden*, and *A Face in the Crowd*. Kazan also made the semiautobiographical film on Greek immigrants *America, America*.

KARL DANE. Rasmus Gottlieb left his native Copenhagen, Denmark, in steerage on the *Oscar II*; he arrived at Ellis Island on February 11, 1916. In Hollywood, he became Karl Dane (1886–1934), and the tall, gangling characters he portrayed captured the attention of audiences in films such as *The Big Parade*, *The Scarlet Letter*, *The Son of the Sheik*, *The Red Mill*, and *Slide, Kelly, Slide*. But sound films ruined his career, and after a string of unsuccessful comedy films such as *Dumbbells and Derbies*, he lost his contract. He then opened a hot dog stand outside his old studio, MGM, but even this failed. When his wife left him, the despondent actor committed suicide.

KARL DANE ENDS LIFE.

Actor in 'Big Parade' Film Had Been Idle Two Years.

HOLLYWOOD, April 14 (Æ).— Karl Dane, 47 years old, motion picture actor, committed suicide late today by shooting himself through the head with a pistol. It was believed in the film colony that he had brooded over his inability to find rôles in recent pictures.

Mr. Dane, who was born in Copenhagen, had a featured rôle in the "Big Parade" and had appeared in more than a score of pictures. He had been idle about two years.

Rudolph Valentino

RUDOLPH VALENTINO. Even though he has been dead for over 80 years, the glorious name of Rudolph Valentino (1895–1926) has never died. Born Rodolfo Guglielmi in Castellaneta, Puglia, Italy, according to his biographer, Valentino came to America in steerage in 1913 and was inspected at Ellis Island. After working in various odd jobs in Little Italy and Central Park, Valentino became a dancer and went into vaudeville. His last booking was in California, and, taking advantage of the opportunity, he became a movie extra. From this point he graduated to substantial roles, which eventually led to stardom thanks to his performance in *The Four Horsemen of the Apocalypse*.

SHULMAN

by the author of HARLOW

VALENTINO

IRVING
SHULMAN

VALENTINO

TRIDENT PRESS

HOLLYWOOD STAR. Valentino's dark, handsome looks caused a revolution in glamour, as previous to his rise actors of his type were cast in sinister and unsavory parts. But Valentino's performances created a sensation as women clamored to each of his films and swooned. The great Valentino was the biggest star of his period, and his films were blockbusters. They include *Blood and Sand, The Sheik, The Conquering Power, The Eagle, Beyond the Rocks, The Young Rajah, Monsieur Beaucaire,* and *The Son of the Sheik,* his last film.

RUDOLPH VALENTINO'S SUDDEN DEATH. The 31-year-old actor's death in August 1926 from peritonitis shocked Hollywood and the world. Crowds of fans were hurt at his bier in New York, and his fiancée, film star Pola Negri, fainted before his casket. In keeping with the wishes of Negri and his show business friends, Valentino was buried in Hollywood, not in Italy.

ALAN MOWBRAY. A striking star known for his excellent diction and upper-class English manners, Alan Mowbray (1896–1969) came to America as a second-class passenger on the SS *President Adams*, which sailed from London in May 1923. He was detained at Ellis Island due to his quota number. Mowbray's films include *Man about Town*, *Our Betters*, *Little Man, What Now?*, *Night Life of the Gods*, and *My Darling Clementine*.

GREGORY RATOFF. Another major character actor who graced film after film was Gregory Ratoff (1897–1960). His credits include *What Price Hollywood?*, *King of Burlesque*, *Sally, Irene and Mary*, *Song of Russia*, *All about Eve*, and *Sabrina*. In 1938, he returned to Ellis Island to direct the scenes of *Gateway*, in which he also performed. Gregoire Ratoff emigrated in steerage on the *Mauritania* in July 1925; his original surname was Ratner.

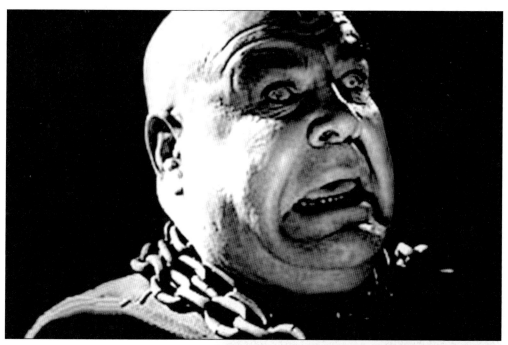

TOR JOHNSON. The Swedish immigrant who first gained public attention as the Super Swedish Angel gained even more notoriety as an actor in horror films. Tore Karl Erik Johansson (1903–1971) first came to the United States in 1919, sailing on the SS *Stockholm*; like many Swedes, the young electrician went to Chicago. His screen career began years later, and his films include *Kid Millions, Alias the Champ, Abbot and Costello in the Foreign Legion, Bride of the Monster, The Unearthly, Night of the Ghouls, Plan 9 from Outer Space,* and his greatest film, *The Beast of Yucca Flats.*

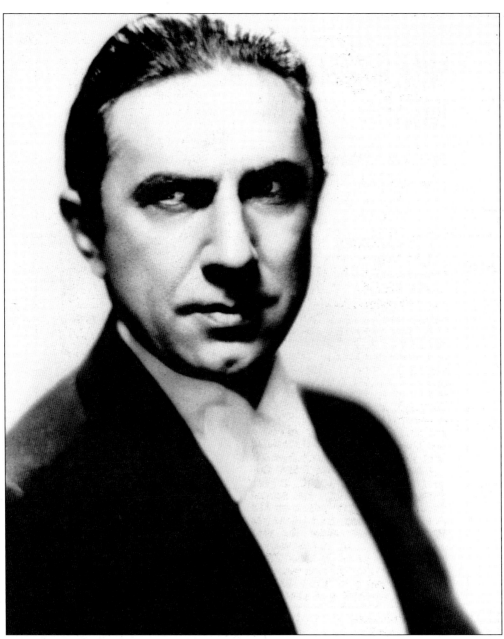

BÉLA LUGOSI. The great Hungarian stage actor unexpectedly came to America as a seaman on board the *Graf Tisza Istvan*, which sailed from Trieste. When given shore leave in New Orleans, the 38-year-old Béla Lugosi (1882–1956) fulfilled his plans. He disappeared from his companions and eventually made his way to New York. There he settled amid his fellow Hungarians and found work in the ethnic theater. Wisely, after six months as an illegal alien, Lugosi voluntarily presented himself at Ellis Island and passed inspection. This was on March 23, 1921. By 1927, he became a Broadway star with his powerful and authentic portrayal of Bram Stoker's Count Dracula. Universal wisely cast him in the 1931 screen version; once more Lugosi's performance was riveting and thrilled audiences everywhere it appeared. Lugosi had achieved theatrical immortality.

BELA LUGOSI DIES; CREATED DRACULA

Portrayer of Vampire Role or Stage and Screen Was Star in Budapest

Belä Lugosi

LOS ANGELES, Aug. 16 (P) —Bela Lugosi, who won international stage and screen fame in the title role of Bram Stoker's mystery, "Dracula," died tonight. He was 71 years old.

A year ago the Hungarian-born actor appealed for help to Los Angeles County authorities, saying he was a narcotics addict and wanted a cure. He was admitted to Metropolitan State Hospital at Norwalk to begin a three-month rehabilitation course. When he was released Mr. Lugosi said he was convinced that he had been cured forever.

During World War I Mr. Lugosi was a lieutenant in the Hungarian Infantry. He served for more than two years on the Serbian frontier and later in Russia. In 1921, after the war and the political revolution in Hungary, he went to New York. He organized a Hungarian dramatic company in which he was producer, director and star.

LEGENDARY STAR. The actor was faced with certain difficulties for, like Antonio Moreno, Vilma Bánky, Pola Negri, and Karl Dane, and many émigré actors, there was a language barrier. Thus Lugosi's expectation of playing suave, romantic roles was not really feasible, and his performance as the vampire sealed his fate; he was now stuck in the horror and mystery genre. Lugosi's best films after *Dracula* include *Murders in the Rue Morgue, The Raven, Son of Frankenstein, White Zombie,* and *The Black Cat.* As he grew older, he accepted decidedly inferior roles and even played caricatures of himself. The last film he was superb in was *Abbott and Costello Meet Frankenstein* (1948). Shortly before his death, he was befriended by independent filmmaker Edward D. Wood Jr., who cast him in starring parts in *Glen or Glenda, Bride of the Monster,* and *Planet 9 from Outer Space.* Using the faded star of horror films was a stroke of genius. Their story was dramatized in the motion picture *Ed Wood* (1994), with Martin Landau portraying Béla Lugosi.

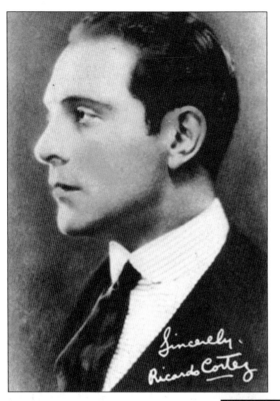

RICARDO CORTEZ. One silent film star who had no trouble in the change to sound films was Ricardo Cortez (1899–1977). Although an immigrant like many others, he quickly captured New York idiom. Jakob Kranz was born in Vienna and arrived at Ellis Island as a steerage passenger on the SS *Rotterdam* in January 1921. In searching for another Rudolph Valentino, Paramount spotted Kranz and promptly dubbed him Ricardo Cortez.

CORTEZ THE STAR. Of course, Cortez was no Valentino, yet he still became a star. His silent films include *The Spaniard*, *Argentine Love* (with Bebe Daniels), *The Torrent* (with Greta Garbo), and *The Sorrows of Satan* (with Lya de Putti). Cortez was also successful in talkies, such as *Montana Moon* (1930, with Joan Crawford) and *Ten Cents a Dance*. He was the original Sam Spade in *The Maltese Falcon* (1931).

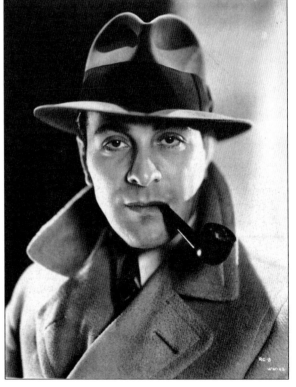

CORTEZ'S LATER WORK. As the 1930s wore on and tastes changed, Ricardo Cortez's popularity waned. Latin lovers were out, and gangsters were in. Cortez drifted toward detective and crime films and away from romance. One of his last starring roles was as Perry Mason in *The Case of the Black Cat*. As his career drifted, Cortez decided it was time for a change. In 1939, he began directing films and only took occasional roles.

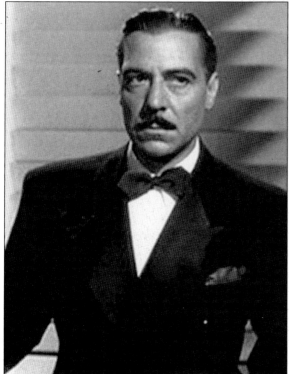

JOSEPH CALLEIA. When Maltese immigrants came to America, they favored settling in Detroit, Michigan. Thus it comes as no surprise that after Joseph Calleia (1897–1975) sailed on the *Olympic* and went to Ellis Island in July 1920, he took the train to Detroit. Calleia, who was a leading character actor in Hollywood, performed in *Golden Boy, The Glass Key, Gilda, For Whom the Bell Tolls, Juarez, The Touch of Evil*, and many other films. He died in Malta.

NIGEL BRUCE. The British actor Nigel Bruce (1895–1953) came to Ellis Island rather unexpectedly; it was merely to get an extension on his visa, which had expired. The actor later went into motion pictures and, of course, achieved his greatest success as Dr. Watson opposite Basil Rathbone's Sherlock Holmes. Bruce's other films include *The Corn Is Green, Suspicion, The Two Mrs. Carrolls,* and *Hong Kong.*

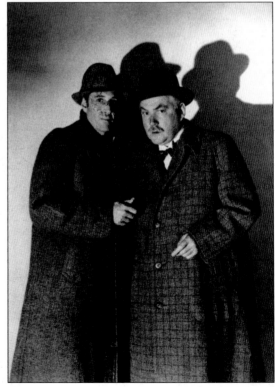

before Dietrich and Garbo, there was Negri...

Life is a Dream in Cinema:

Pola Negri

A Film by
Mariusz Kotowski

with
Hayley Mills

Eli Wallach

narrated by
Cyndi Williams

Produced by
Heidi Hutter at
Bright Shining City Productions
www.brightshiningcity.com

POLA NEGRI. Actress Pola Negri (1894–1987) was a Hollywood superstar in the 1920s. Her films bore titles such as *Gypsy Blood, The Cheat, Forbidden Paradise, Lily of the Dust,* and *East of Suez.* She was truly a femme fatale. But the Polish actress's Hollywood reign came to an end with the advent of talking pictures, and she bade adieux to America and returned to Europe. In Berlin, she delighted audiences with *Mazurka, Gräfin Volescu,* and *Der Weg nach Shanghai.* But the nazification of the German film industry ended her work there, and she moved to the French Riviera. At the fall of France, Negri soon joined others fleeing Europe. In July 1941, she sailed from Lisbon on the *Excalibur.* But since she had lost her reentry permit, she ran into trouble. The *New York Times* gave full scope to the story with a photograph of the actress on the ferryboat *Ellis Island.* The headline ran, "Screen Actress Returns by Way of Ellis Island." Negri sorted out her problem and gave autographs to the immigration inspectors.

POLA NEGRI IN AMERICA. A native of Lipno, Poland, Pola Negri was born Barbara Apolonia Chalupiec. She became a film star in Poland and Germany before moving to Hollywood in 1921. After her return in 1941, she became a U.S. citizen (1953) and made her last films, *Hi Diddle Diddle* (1943) and *The Moonspinners* (1964). She died in San Antonio, Texas, and is buried in a Roman Catholic cemetery in Los Angeles.

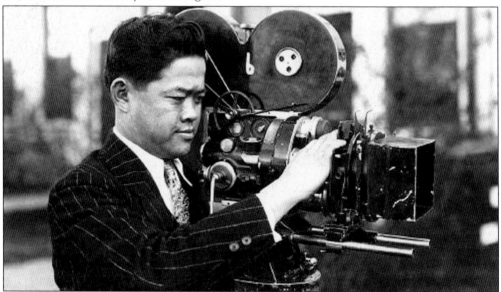

JAMES WONG HOWE. One of Hollywood's greatest cinematographers, James Wong Howe (1899–1976) came to join his father in the Pacific Northwest in 1904. The youthful native of Canton, China, was originally called Wong Tung Jim. Thanks to winning the praise of silent film star Mary Miles Minter, Howe emerged as a leading cameraman in Hollywood and eventually won Academy Awards in the 1950s for *The Rose Tattoo* and *Hud*.

Eight

FIGURES OF CONTROVERSY

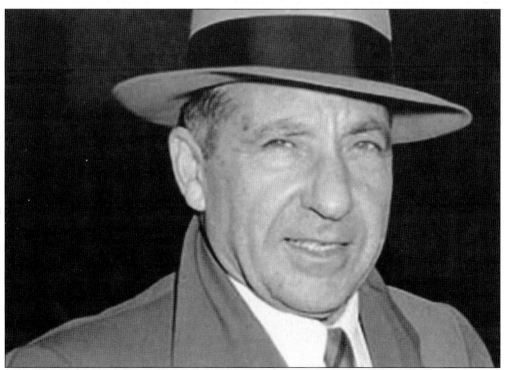

FRANK COSTELLO. Gangster Frank Costello (1891–1973) was born Francesco Castiglia in Calabria, Italy, and came to the United States around 1900; the family settled in Italian Harlem. Costello became one of the closest advisors to New York Mafia chief Charles "Lucky" Luciano. His negotiating skill and ties to politicians earned him the nickname "Prime Minister of the Underworld."

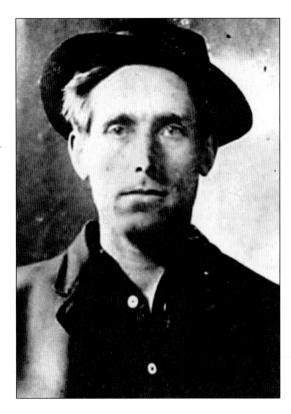

JOE HILL. Born Joel Hagglund in Gavle, Sweden, Joe Hill (1879–1915) came to the United States with his bother, Paul, in 1902 seeking work as laborers. While in California, Joe Hill (or Hillstrom) joined the International Workers of the World (Wobblies) and began gaining attention as a composer and folk singer of workers' protest songs. Several of them were printed in the organization's *Little Red Song Book* in 1911. Hill's arrest and execution for murder in Utah created an international uproar.

HILLSTROM IS CREMATED.

Attacks on Utah Officials Feature of Funeral of I. W. W. Poet.

Special to The New York Times.

CHICAGO, Nov. 25.—Joseph Hillstrom, alias Joe Hill, poet laureate of the I. W. W., received about such a funeral today as he would have desired, according to his friends.

Anarchists, Nihilists, some Socialists, "bums" and hoboes generally, of whom less than 10 per cent. were American, assembled for the ceremony in the West Side Auditorium. Three thousand persons managed to get inside, while outside twice as many battled with the police to get in.

The red flag floated undisturbed at every turn. The pine coffin containing the body of the man executed by the Utah authorities for murder, was draped in a red flag.

There was no touch of religion in the ceremony. Bitter attacks upon the existing social system and threats against the Utah authorities were made by the orators.

The gathering was greatly augmented by the striking garment workers, who chose the occasion for a demonstration, passing contribution boxes and peddling literature.

On a banner that hung over the coffin was this inscription:

IN MEMORIAM, JOE HILL.

We never forget.

Murdered by the authorities of the State of Utah, Nov. 19, 1915.

The ceremonies were opened by a quartette, clad in overalls, which sang one of Hillstrom's songs. Then a Polish girl, introduced as the "Rebel Girl," by W. D. Haywood, sang a song written by Hillstrom while awaiting execution and dedicated to his sweetheart.

Jim Larkin, the Dublin labor leader, and Haywood assailed the officials of Utah. Judge Hilton of Denver warned Utah that a day of reckoning was coming.

Eight men then shouldered the coffin and led a street procession nearly a mile in length. All along the line of march the crowd yelled and sang Hillstrom's songs. Police battled with the disorderly members all the way to the railway station.

At Graceland Cemetery more addresses were made. The body was then cremated and the ashes will be delivered to the I. W. W. for distribution.

LUCKY LUCIANO. Born Salvatore Lucania in Sicily, Charles "Lucky" Luciano (1897–1962) came to the United States with his family in 1906; they settled in New York. Luciano drifted into crime and criminality from an early age and met his lifelong companions Meyer Lansky, Bugsy Siegel, and Frank Costello. In the 1920s, Luciano consolidated his position as a gang leader and eventually gained control of the New York mob. He streamlined la Cosa Nostra and redesigned it into a modernly organized American crime business. Luciano was finally convicted for running a prostitution racket and was imprisoned in Sing Sing. In 1946, he was deported to Italy. Although abroad, he remained in control of the Mafia. He died in Naples.

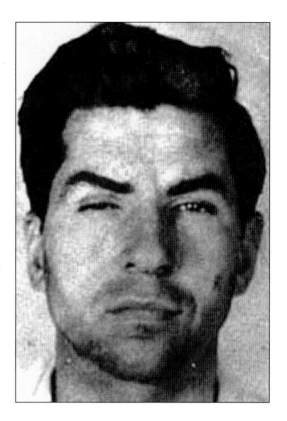

LUCIANO LEAVES PRISON

Taken to Ellis Island, Where He Will Be Deported to Italy

Special to THE NEW YORK TIMES.

OSSINING, N. Y., Feb. 2— Charles (Lucky Luciano) Lucania, 47 years old, former vice czar and racketeer, left Sing Sing prison today in custody of two Federal Immigration Bureau agents to be deported to Italy. Luciano, pardoned recently by Governor Dewey, who as District Attorney of New York County originally convicted him, with the condition he be deported, had been in Sing Sing since Jan. 9.

He was originally lodged there June 18, 1936, transferred to Clinton prison at Dannemora July 2 the same year, later moved to Great Meadow prison at Comstock and after receiving the pardon moved back to Sing Sing.

James Sessa and Thomas Scanlon, immigration agents, took him to Manhattan in an automobile en route to Ellis Island.

The prisoner originally received thirty to fifty years on a compulsory prostitution charge. If Luciano violates the terms of his pardon, and is found in this country after being banished, he will risk having to serve forty-one more years.

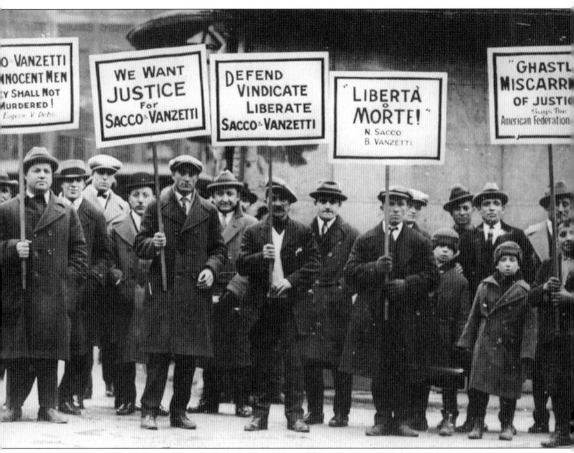

SACCO AND VANZETTI. The trial and execution of Nicola Sacco and Bartolomeo Vanzetti, two Italian immigrants, was a cause celebre during the 1920s; it underlined the real hostility that some Americans felt toward certain classes of immigrants. Vanzetti (1888–1927) was born in Villafalletto, Italy. He came to the United States as a steerage passenger on the *La Provence*, which sailed from Le Have, France, and arrived in New York in June 1908. Listed as a laborer, he eventually established himself as a fishmonger. He befriended Nicola Sacco, who shared his anarchist convictions. In 1927, the two were convicted of murder on circumstantial evidence and executed by the Commonwealth of Massachusetts.

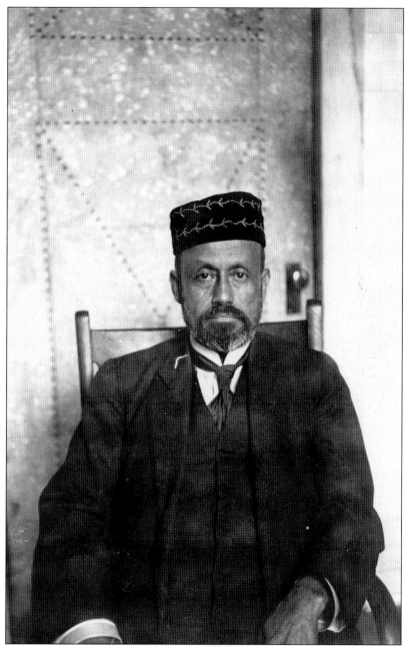

CIPRIANO CASTRO. One of the most sensational detentions in Ellis Island's history was that of Gen. Cipriano Castro (1858–1924), the former president of Venezuela. On December 31, 1912, ex-president Castro arrived as a first-class passenger on the *Touraine*. Orders were sent to Ellis Island's commissioner from Washington to detain him on any pretext. American animosity toward Castro dated back to days of defiance and independent-mindedness during his presidency. At Ellis Island, former president Castro was photographed by chief clerk Augustus Sherman in his detention quarters. A board of special inquiry ordered his exclusion, and all his appeals were rejected. Finally he was ordered released by a federal court. He later settled in Puerto Rico, where he died.

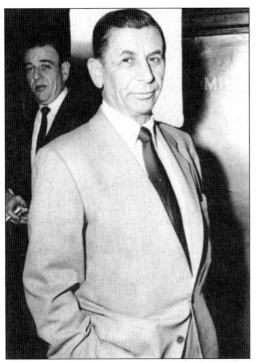

MEYER LANSKY. A Polish Jew, Meyer Lansky (1902–1983) was born in Grodno, Russia, as Majer Suchowlinski. The Suchowlinskis joined the flow of emigration in 1911 and settled in Manhattan's Lower East Side. He and Charles "Lucky" Luciano became pals in their boyhood, and their friendship remained solid for the rest of their lives. In the 1930s, Lansky extended the mob's criminal operations to Cuba. The photograph at left was taken in 1958.

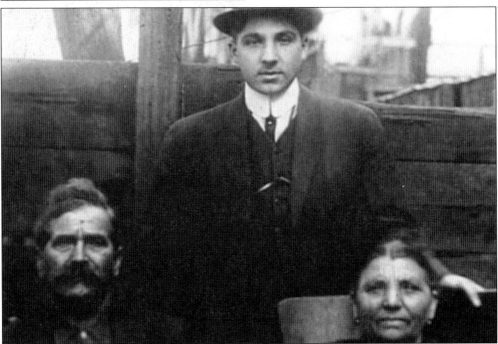

ALBERT ANASTASIA. Another member of the New York mob, Albert Anastasia (1902–1957) headed its contract killing unit, Murder, Inc. Umberto Anastasio was born in Italy, and he came to New York as a seaman in 1919. He worked along the waterfront where his murderous appetite was whetted. He became a devoted follower of Luciano and soon worked his way to the position of leader of Murder, Inc. This photograph shows him with his parents.

MARCUS MOSIAH GARVEY. The founder of the Universal Negro Improvement Association and "back to Africa" movement was born Marcus Mosiah Garvey (1887–1940) in Jamaica. He came to the United States in 1916 and settled in New York, where he introduced his ideas and founded the Black Star Steamship Line and the *Negro World*, a periodical. He urged African Americans to return to Africa and negotiated a settlement agreement with the Liberian government. Garvey was investigated for mail fraud, and in 1923, he was convicted and sentenced to five years imprisonment. In 1927, Pres. Calvin Coolidge commuted his sentence, and he was deported to Jamaica. He resumed his activities in Jamaica, and in 1935, he moved to England, where he died of a stroke five years later.

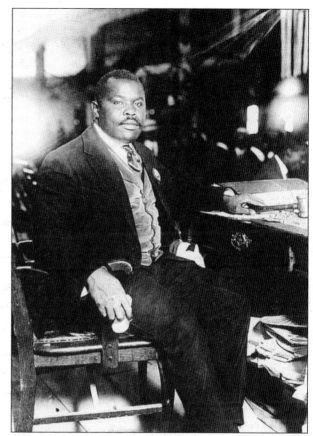

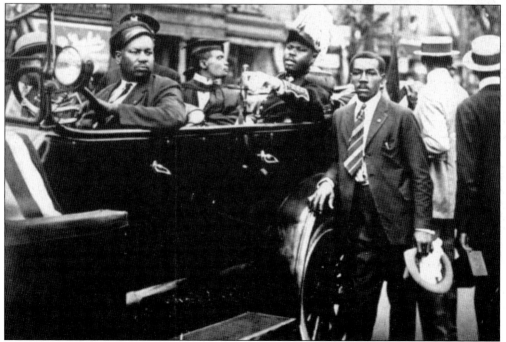

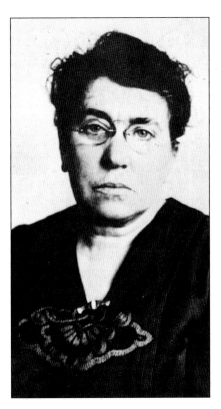

EMMA GOLDMAN. Known by her critics as "Red Emma," Emma Goldman (1869–1940) was born in Russia (Lithuania), and she immigrated to the United States in 1885 to work in a factory. In 1889, she was converted to anarchism and went on speaking tours throughout the country. Imprisonments did not deter her, nor did threats by the police. Finally in 1919, she was arrested and brought to Ellis Island and deported to Russia.

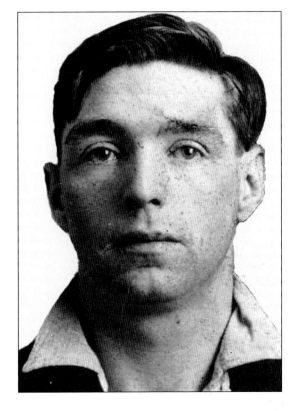

OWNEY MADDEN. Another member of the New York mob was Owen Madden (1891–1965). Madden was born in Leeds of Irish parents and left England for New York on the SS *Teutonic* in June 1902. In the 1920s, he ran the Cotton Club in Harlem and for years was a top boxing promoter (he managed Primo Carnera's fights). In 1935, with things getting hot, Madden left racketeering and retired to Arkansas.

COUNT ARTHUR CHEREP-SPIRIDOVITCH. In December 1920, mysterious Russian émigré Count Arthur Cherep-Spiridovitch came to the United States on board the SS *Aquitania*. He was briefly detained at Ellis Island, as he had been passing out anti-Jewish pamphlets during the voyage; efforts to exclude him on various pretexts were overruled. Cherep-Spiridovitch (1858–1926) was certainly a bitter and confused man when he settled in New York. The things to which he had dedicated his life had fallen before his shocked eyes: the imperial Romanoffs, the aristocracy, and all the traditions. He grasped at the easiest explanations, one of which was the age-old prejudice against Jews. He published his views in *The Secret World Government or "the Hidden Hand"* just before he was killed from gas poisoning. The count, a Polish Catholic, was formerly a general in the Russian army.

THE SECRET WORLD GOVERNMENT

OR

"THE HIDDEN HAND"

The Unrevealed in History

100 Historical "Mysteries" Explained

CHEREP-SPIRIDOVICH DIES HERE FROM GAS

Count Found in Staten Island Hotel Room on Eve of Big Slav Meeting.

HOPED TO UNITE PEOPLE

Nobleman Spent Years Trying to Organize Them—Fought Under Czar, Losing Four Sons.

Count Arthur Cherep-Spiridovich, whose ambition it was to unite the millions of Slavs all over the world, died of gas poisoning yesterday in his room at Barrett Manor, Arrochar, S. I. Asphyxiation followed the accidental dislodging of a petcock in a gas radiator.

Count Cherep-Spiridovich died on the eve of a Slav convention which was to have begun on Monday after years of planning. He had held many conferences on his scheme of Slav union and had sent out considerable literature on the subject.

HANNAH CHAPLIN. In 1921, Charlie Chaplin's mother, Hannah Chaplin, came to the United States but was detained at Ellis Island because of her mental state. The former star of Gilbert and Sullivan operettas had suffered shell shock during the Zeppelin bombing raids over London. At last, Charlie's bond guaranteeing her care was accepted, and she went to Hollywood. However, the Department of Labor periodically tried to deport her from the United States, as her "temporary" visit was not thought to help in her recovery. The department gave up on her case, and the old actress died in Glendale, California, in 1928.

"PRINCE" MICHAEL ROMANOFF. The complicated and peculiar case of the famous eccentric who passed himself off for years as Prince Michael Romanoff is remarkable, to say the least. The debonair and elegant man with an aristocratic air and Oxford accent was originally a poor Jewish immigrant orphan named Harry F. Gerguson. (Hershel Geguzin in Russian). As Prince Romanoff (1890–1971), he was supposed to be one of the few imperial Romanoffs to have survived the Bolshevik Revolution. In 1932, Romanoff stowed away on a French steamer and was turned in to immigration officers at Ellis Island. But before they could deport him, he escaped. The search for him in Manhattan finally bore fruit, and he was once again in custody. But his charming eccentricity and madcap conduct endeared him to the public, and he was helped out of the tangle he was in and released. He was straightway booked into vaudeville. But his road was still a rocky one. It was not until he made his way to California that his fortunes would begin to turn.

GERGUSON INDICTED ON PERJURY CHARGE

Glib Talk of 'Romanoff Prince' the Subject of 13 Counts Found by Grand Jury.

TO BE ARRAIGNED TODAY

He Will Halt Vaudeville Career to Face Accusation of False Swearing at Ellis Island.

Harry F. Gerguson, whose Oxford accent and glib talk at one time convinced many that he was "Prince Dmitri Michael Obolenski-Romanoff," may have talked his way into a long term in jail, when he recently tried to explain to immigration authorities at Ellis Island just what he was doing in the United States when he was supposed to have been deported.

The "Prince," who is free in bail of $2,500 and is appearing before vaudeville audiences, pending further investigation by a board of inquiry on the island, was indicted yesterday by the Federal grand jury in two bills.

ROMANOFF'S. In 1936, Michael Romanoff arrived in Los Angeles, and in 1939, thanks to the help of several film stars who embraced Romanoff as one of their own, he opened Romanoff's, an exquisite restaurant. For almost 30 years, the "Prince's" would be a favorite of the stars, including Ronald Colman, Myrna Loy, James Cagney, Charlie Chaplin, Humphrey Bogart, W. C. Fields, Robert Benchley, and Edward G. Robinson.

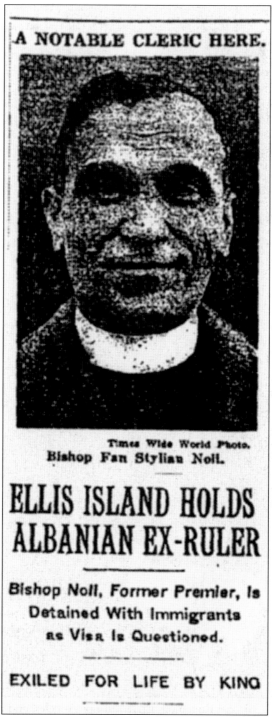

A NOTABLE CLERIC HERE.

Times Wide World Photo.
Bishop Fan Stylian Noli.

ELLIS ISLAND HOLDS ALBANIAN EX-RULER

Bishop Noll, Former Premier, Is
Detained With Immigrants
as Visa Is Questioned.

EXILED FOR LIFE BY KING

FAN S. NOLI. In 1932, Bishop Fan S. Noli (1882–1965) was briefly detained at Ellis Island. He spent the remainder of his life here, and, although still concerned for Albania, he devoted much time to scholarship, authored several books, and was an authority on Byzantine music. At the time of his death, he was an archbishop.

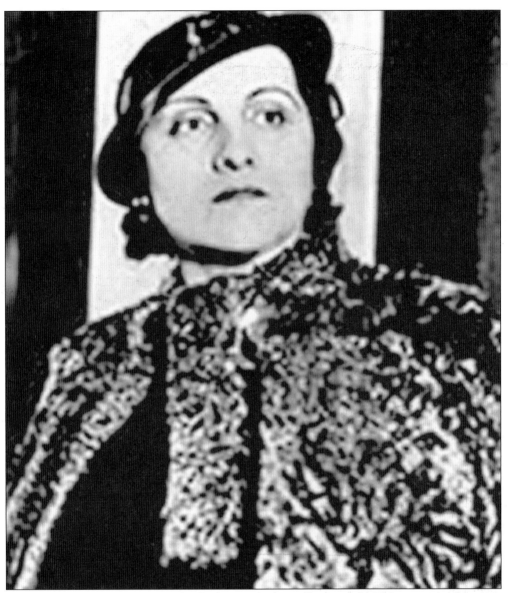

ANNA SAGE. The "Woman in Red" who betrayed John Dillinger to the FBI was none other than Romanian immigrant Anna Sage (1889–1947). She came to the United States as Anna Ciolak, wife of Mihai Ciolak in 1919, and she went back to Romania in 1923 or 1924 to visit her mother, Marta Cumpanas. She returned on the *Majestic* on September 2, 1924. She soon left her husband and became a brothel keeper. Later she temporarily gave up this life and married Alexander Suciu; they anglicized their name to Sage. She left him and went back to the brothel. When the INS notified her that they were taking deportation proceedings against her, she contacted the FBI and offered to help them get John Dillinger in exchange for money and assistance to prevent her deportation. She and another woman arranged to go with Dillinger to Chicago's Biograph Theatre in July 1934. That night, the FBI were ready, and when the suspicious Dillinger went for his gun, they shot him dead.

THE LAST OF THE WOMAN IN RED. Anna Sage was immediately placed under security. She was only referred to as the "Woman in Red." Soon though her name was finally given to the press, which was clamoring to know all about her. She was paid $5,000 reward (she had expected more), but nothing was done about her pending deportation case. In spite of appeals to the INS and Department of Labor, she was arrested in 1936 and put on the deportation train that halted in Chicago, before proceeding to New York. Anna Sage arrived at Ellis Island, where final arrangements were made for her departure. She was locked in her stateroom on board her steamer and soon was back in Timişoara, Romania. In spite of her vows, she never returned to the United States.

ON WAY TO DEPORTATION

Woman Who Betrayed Dillinger Due at Ellis Island Today.

CHICAGO, April 26 (*P*).—Mrs. Anna Sage, the "woman in red," sped eastward today toward Ellis Island and deportation to her native Rumania as an undesirable alien. The woman who led police and Federal agents to John Dillinger was on a train bearing thirty-one other deportees.

The train is due at Jersey City at 5 A. M. tomorrow after stops at Cleveland and Buffalo to pick up other aliens. From Jersey City the deportees were to be taken to Ellis Island to await ships.

The Jersey City police have made special preparations for the arrival this morning from Chicago of Mrs. Anna Sage. Deputy Police Chief Charles Wilson announced yesterday that he has assigned a special detail of police to escort Mrs. Sage and guard her while she is in Jersey City.

DILLINGER BETRAYER, 'WOMAN IN RED,' DIES

BUCHAREST, Rumania, April 28 (*P*)—"The Woman in Red," who led John Dillinger into an FBI trap that resulted in the killing of America's Public Enemy No. 1 in Chicago thirteen years ago, died last Friday in a quiet town in southwestern Rumania, the Timisoara newspaper Vestul said today.

Ana Cumpanas, known in the United States as Mrs. Anna Sage, was 58 years old at the time of her death and a legal autopsy showed that she had succumbed to a liver ailment.

Deported by the United States Government in 1936, Mrs. Cumpanas returned to her native Rumania where she made her home at Timisoara, leading the life of a well-to-do citizen.

Despite her relative opulence, the newspaper said, Mrs. Cumpanas maintained to the end of her life that United States Federal authorities had "cheated" her out of the $70,000 reward for which, she contended, she had agreed to "put

JAN VALTIN HEARING ON DEPORTATION ENDS

Ellis Island Inspectors to Send Report to Justice Officials

The government's deportation case against Richard Krebs, who is known as Jan Valtin, author of the book "Out of the Night," terminated yesterday after a brief hearing on Ellis Island at which the author testified briefly about his activities in aiding the United States Government with information about Communist and Nazi activities in this country.

Mr. Valtin has testified for the Dies committee and has in other ways given the Federal authorities the advantage of his past experience in political activities. He has now rejected the subversive influences with which he was formerly associated and has expressed the wish to serve the cause of democracy.

The record of the hearing conducted in recent weeks on Ellis Island is to be sent to the Department of Justice in Washington together with recommendations written by the Ellis Island immigration board.

Hugo Pollock, Mr. Valtin's attorney, said yesterday he would file a brief to accompany the immigration board's findings, in which he would point out that Mrs. Valtin, an American citizen, is dependent on the author for support and that she is expecting a child.

When Mr. Valtin and his attorney returned from Ellis Island he appeared to be in good spirits and said that he was confident he would not be deported. He spoke of the fact that he had broken all ties with the Communist party and that he had been fighting communism and nazism.

RICHARD KREBS, ALIAS "JAN VALTIN." Another unusual case was that of the German double agent Richard Krebs, who defected to the United States in 1939. Krebs (1905–1951) became a Soviet spy in the mid-1920s. After the rise of the Nazis, he joined the Gestapo but remained in the service of the USSR. But the Soviets mistrusted him, and before they could send him to Russia, he fled to the United States. In 1940, he published his reminiscences, *Out of the Night*, under a pseudonym, Jan Valtin. It was quite a success. On the United States' entry into the war, Germans living in the United States were proclaimed alien enemies, and the FBI arrested all Germans with suspicious connections. Krebs was an obvious choice for investigation and was taken to Ellis Island, where he remained for more than a year. After his release, he complained that his health had broken while in detention on the island. Krebs was also the author of *Children of Yesterday* and three novels, *Bend in the River*, *Castle in the Sand*, and *Wintertime*.

122

FRITZ KUHN IS DEPORTED

DEPORTEES, POW'S HEAD FOR GERMANY

715 Men Leave Under Guard on Two Vessels—Fritz Kuhn, Ex-Bund Leader, Included

Two aptly named American transports left New York yesterday with 715 Germans who are bound for their demolished homeland under guard.

Onto the Winchester Victory, tied up at Pier 1, the Battery, stumbled Fritz Kuhn, former German bundist and ex-convict, lugging two heavy suitcases from the apron of an Ellis Island ferryboat, at the tag-end of a line of 499 German undesirables. Dressed in khaki trousers and shirt, Kuhn struggled along with his baggage, as did the others, all wearing numbered cards in their hatbands. One brought a laugh when he appeared with a suitcase plastered with bright tourist stickers of another day.

The pier, across from the Whitehall Building, was heavily guarded by Federal men, including Department of Justice agents, Customs officers and Coast Guard men.

Kuhn Had a Grim Face

The one-time Nazi leader boarded the Winchester Victory with a grim face, but as he crossed the pier he paused while a photographer took his picture and, when he was asked for a smile and a good-by wave, he complied with a forced grin. A fellow-deportee remarked "It's good-by all right."

The other ship was the Frederick Victory, which took on 226 German prisoners of war at Pier 9, North River, a few blocks north of the Winchester Victory. The Germans arrived in a convoy of covered trucks from Camp Dix, which drove right up to the gangplank where the men climbed down and walked up the gangway under guard.

Army officials said the POWs were being sent back to Germany to work in the coal mines, a life that obviously will be far different from the work they have been doing, for all were healthy looking and deeply tanned.

A veterans' advisory committee, composed of World War I and II veterans, will have as its concern that ex-service men and women obtain the assistance and understanding they need. A business advisory board will give advice to veterans interested in establishing small businesses. There will be a labor board to provide information on questions of membership, initiation fees, seniority and other union problems. Both the American Federation of Labor and the Congress of Industrial Organizations for New York City have already designated full-time representatives for this service.

The former Bund leader arriving from Ellis Island

Associated Press

FRITZ KUHN. Potentially divided loyalties sometimes create an atmosphere of suspicion toward immigrants, and although such feelings are almost always unfounded, in the case of Fritz Kuhn, it would have been justified. Kuhn (1896–1951) immigrated to the United States from Germany in 1928. Inspired by the rise of the Nazis in his homeland, Kuhn became active in pro-Nazi organizations and, in 1936, became leader of the German American Bund. Kuhn aspired to be America's führer and strengthened and expanded the organization and aggressively raised its public profile. At the outbreak of war, the FBI arrested most members of the bund, and Fritz Kuhn was sent to Ellis Island; from there he was interned for the remainder of the war at a camp in Crystal City, Texas. In 1946, he was sent back to Ellis Island and from there deported to Germany.

"I publish my protest with the book on Melville because, as I have shown, the book as written is a part of my experience. It is also a claim before the American people, the best claim I can put forward, that my desire to be a citizen is not a selfish nor a frivolous one."

C. L. R. James

from Chapter VII, p. 201

An Original book; not a reprint.

C. L. R. JAMES. The historian and author C. L. R. James (1901–1989) was a native of Trinidad and moved to England and, in 1938, to the United States. The Marxist scholar apparently was not detained for his political views, but the charge simply was that he had overstayed his visa—by 10 years. He was arrested and taken to Ellis Island in June 1952; there he remained until October. In that time (he had made an appeal to stay in the country), he wrote a book in which he described his detention on the island and his treatment there. The book was published in 1953; its title is *Mariners, Renegades and Castaways*. All the same, James was deported to England. Pictured is a copy of the first printed edition of the work.

MARINERS RENEGADES and CASTAWAYS

by C. L. R. JAMES

THE STORY OF

HERMAN MELVILLE

AND THE WORLD WE LIVE IN

"If, then, to meanest mariners, and renegades and castaways, I shall hereafter ascribe high qualities, though dark; weave round them tragic graces; if even the most mournful, perchance the most abased, among them all, shall at times lift himself to the exalted mounts; if I shall touch that workman's arm with some ethereal light; if I shall spread a rainbow over his disastrous set of sun; then against all mortal critics bear me out in it, thou just Spirit of Equality, which hast spread one royal mantle of humanity over all my kind!"

Melville's Moby-Dick

WRITER RELEASED FROM ELLIS ISLAND

Voskovec, a Czech, Had Been Held 10½ Months in 'Prison' on Security Charges

George Voskovec, Czech dramatist and actor, was released yesterday from Ellis Island after detention for ten and a half months on unspecified security charges.

The 45-year-old writer, former employe of the Office of War Information here, said he was "glad and moved that I was right in betting on American fairness and waiting for justice." However, he made no effort to hide his resentment at the slowness of the processes of justice and at the conditions h_ endured on Ellis Island.

The Commissioner of Immigration and Naturalization ordered release of Mr. Voskovec on the basis of arguments presented by his attorney in Washington Feb. 12 on appeal from an adverse ruling, by a 2-to-1 decision, of a board of special inquiry here three months ago.

GEORGE VOSKOVEC. The Czech actor George Voskovec (1905–1981) came to the United States in 1939 and, in 1946, returned to Prague to reopen his theater. But when the Communists illegally seized power in 1948, he left for Paris. On May 16, 1950, on his return to New York, he was met by immigration agents and taken to Ellis Island. Someone accused him of having worked with the Communists while in Czechoslovakia. This charge he denied and got a number of reliable witnesses to testify on his behalf. But in December, the INS ordered his deportation. Desperate, Voskovec appealed the decision. The Justice Department in Washington agreed, and he was released on April 2, 1952, after 10 months on Ellis Island. On leaving, he gave the *New York Times* reporter his impression of Ellis Island: "I want to go on record that it's a disgusting place—a prison." In December 1955, a dramatized version of Voskovec's experience was presented on television. It was called *I Was Accused*, and the players were Voskovec, Hurd Hatfield, Alexander Scurby, and Cameron Prud'homme.

BIBLIOGRAPHY

Corsi, Edward. *In the Shadow of Liberty: The Chronicle of Ellis Island*. New York: Macmillan, 1935.

Cowen, Philip. *Memories of an American Jew*. New York: International Press, 1932.

James, C. L. R. *Mariners, Renegades and Castaways*. New York: self-published, 1953.

Lowenstein, Evelyn. *Picture Book of Famous Immigrants*. New York: Sterling Publishing, 1962.

Monush, Barry. *Encyclopedia of Hollywood Film Actors*. New York: Applause, 2003.

Moreno, Barry. "Berühmte Ellis-Island-Einwanderer der ersten Generation." In *Hoffnung Amerika: Europäische Auswandererung in die Neue Welt*, edited by Karin Schulz. Bremerhaven, Germany: 1994.

———. *Encyclopedia of Ellis Island*. Westport, CT: Greenwood, 2004.

Novotny, Ann. *Strangers at the Door: Ellis Island, Castle Garden and the Great Migration to America*. Riverside, CT: Chatham, 1971.

Pejsa, Jane. *Romanoff, Prince of Rogues*. Minneapolis: Kenwood Publishing, 1997.

Prigozy, Ruth. *The Life of Dick Haymes: No More Little White Lies*. Jackson: University Press of Mississippi, 2006.

Stewart, Ray. *Immortals of the Screen*. New York: 1965.

INDEX

ACROSS AMERICA, PEOPLE ARE DISCOVERING SOMETHING WONDERFUL. *THEIR HERITAGE.*

Arcadia Publishing is the leading local history publisher in the United States. With more than 3,000 titles in print and hundreds of new titles released every year, Arcadia has extensive specialized experience chronicling the history of communities and celebrating America's hidden stories, bringing to life the people, places, and events from the past. To discover the history of other communities across the nation, please visit:

www.arcadiapublishing.com

Customized search tools allow you to find regional history books about the town where you grew up, the cities where your friends and family live, the town where your parents met, or even that retirement spot you've been dreaming about.